The Assateague Ponies

The
Assateague
Ponies

RONALD R. KEIPER

Tidewater Publishers : Centreville, Maryland

We gratefully acknowledge the cooperation of
the National Park Service toward the preparation of the map.

Library of Congress Cataloging-in-Publication Data

Keiper, Ronald R.
 The Assateague ponies.

 Bibliography: p.
 Includes index.
1. Chincoteague pony. 2. Ponies—Behavior.
3. Mammals—Assateague Island National Seashore
(Md. and Va.)—Behavior. 4. Mammals—Behavior.
5. Assateague Island National Seashore (Md. and Va.)
I. Title.
SF315.2.C4K45 1985 599.72'5 84-26682
ISBN 0-87033-330-5

Manufactured in the United States of America
First edition, 1985; fifth printing, 1999

To my wife Linda
who shared my life on Assateague with our friends the ponies and
who has also served as my sounding board for ideas and the source of
my inspiration when times were hard

To my children Amy and Eric
who I hope will have as much freedom in leading their lives as do the
Assateague ponies

And to my friend and colleague George N. Payette
who provided strong support of my endeavors over the years and
greatly helped in the writing of this book

Contents

Foreword

SINCE the creation of Assateague Island National Seashore in 1965, the greatest interest in natural history by visitors has been the horses which roam throughout the thirty-seven mile long barrier island. Visitors, steeped in the legend made famous by Marguerite Henry's book, *Misty of Chincoteague,* often arrived with the expectation that the National Park Service could provide in-depth information about any aspect of this unique resource.

How many horses are there? On what do they feed and where do they water? When and where are foals born? What happens during winter? A myriad of questions stumped employees in the early years of seashore operations.

The park service was not without its own list of professional concerns: What are the population dynamics and what are its limits? Are native deer or nesting shorebirds affected by their presence? What is happening to the beach grass and fragile dunes?

As popularity soared with the new national seashore, so too did interactions between horses and humans. Bite and kick injuries and property damage to camping equipment increased with unsettling regularity. The seashore staff faced new questions relative to visitor safety and a healthy herd of animals: Would new generations of horses become acclimated to roads and campgrounds, rather than the wild? How could we convince visitors that these animals are unpredictable and best enjoyed from a safe distance?

It became increasingly obvious that proper management of our unique resource would depend on solid research. We needed material on social behavior and biological characteristics to satisfy inquiries

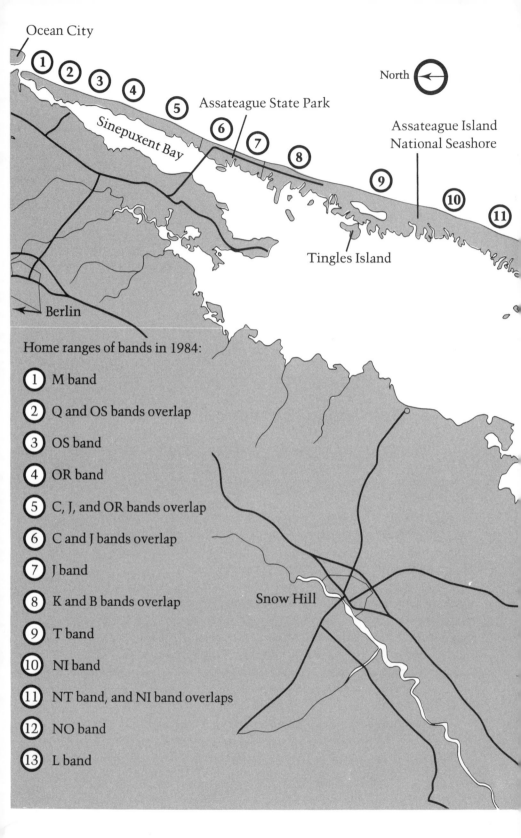

Ocean City

North

Assateague State Park

Assateague Island
National Seashore

Sinepuxent Bay

Tingles Island

Berlin

Snow Hill

Home ranges of bands in 1984:

1. M band
2. Q and OS bands overlap
3. OS band
4. OR band
5. C, J, and OR bands overlap
6. C and J bands overlap
7. J band
8. K and B bands overlap
9. T band
10. NI band
11. NT band, and NI band overlaps
12. NO band
13. L band

Home Ranges of Assateague Ponies

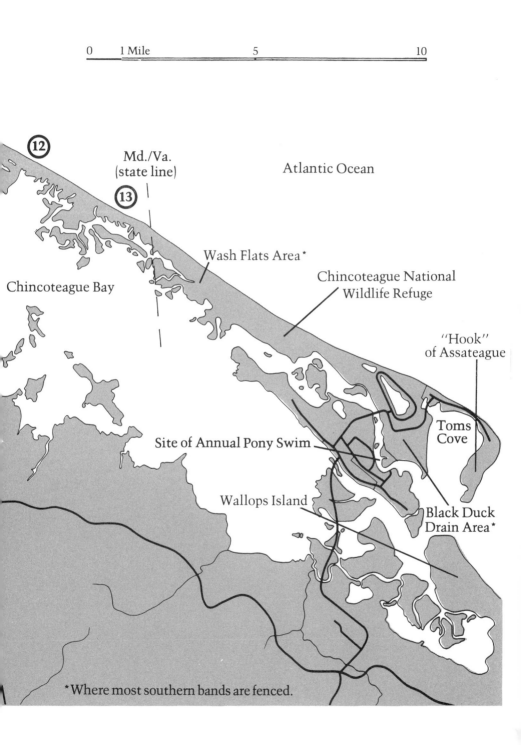

0 1 Mile 5 10

⑫

Md./Va.
(state line)

Atlantic Ocean

⑬

Wash Flats Area*

Chincoteague Bay

Chincoteague National
Wildlife Refuge

"Hook"
of Assateague

Site of Annual Pony Swim

Toms
Cove

Wallops Island

Black Duck
Drain Area*

*Where most southern bands are fenced.

by visitors and our own management concerns. In formulating plans to conduct basic research on the wild horses, the National Park Service knew that the reseacher would have to be nearly as unique as the subject. The successful candidate would be one who could treat the animals with a purely scientific approach and who would begin with no preconceived ideas about the horses or how they should be managed. The researcher would have to be dedicated to the prospect of several years of labor in all seasons, and in an environment notorious for heat and humidity, damp cold, high winds, and clouds of biting insects. While the subject of wild horses sounds glamorous, and a seashore setting seems idyllic, this research activity was to be no picnic!

In 1975, we found just the right person in Dr. Ronald Keiper who stepped forward from Pennsylvania State University and indicated a strong desire to participate. An associate professor of zoology, he was well versed in the biological sciences and eager to study the horses.

The park service brought Dr. Keiper and the special challenge of the Assateague ponies together. The wealth of data that has since flowed forth has proven that we made a wise choice indeed. Thanks to Dr. Keiper, naturalists now know the answers to so many questions and park managers can apply good scientific research in the decision making process.

In this interesting account of the fruits of his research labors, the reader will detect Ron Keiper's dedication and devotion to his work. Those of us who serve at Assateague have known all about that for quite some time.

Larry G. Points
Chief of Interpretation
Assateague Island National Seashore

The Assateague Ponies

1.
An Introduction to
the Ponies and the Research

No one knows the exact origin of the Assateague Island ponies, but several theories explain their presence. The most romantic explanation suggests that a Spanish galleon, carrying horses to the colonies in South America, shipwrecked off the island in the late 1500s, and the horses stem from survivors of that wreck.

Another belief holds that pirates may have deposited a few horses on the island to serve as food when they would next pass that way. The pirates never returned—but the horses flourished.

The most likely hypothesis is that the ponies descended from horses concealed by early Eastern Shore colonists who sought to escape taxation and fencing requirements; ponies could graze and reproduce until needed for plowing or riding. They were then rounded up and brought back by boat to the mainland. However they arrived, the ponies have lived on Assateague for at least three hundred years.

A number of other populations of free-ranging horses or ponies like those at Assateague are found throughout the world. Some live on islands while others roam over inland regions. Some populations have been studied by scientists, others remain unstudied. All these populations consist of feral animals, animals that have been domesticated but have since returned to the wild. Apparently there are no groups that have never been domesticated, and thus there are no truly wild horses in existence.

There are the Misaki horses in Japan, the New Forest ponies in England, and the Camargue horses living in the delta of the Rhone River in southeastern France. In western continental United States there are wild horses in the Granite Range of northwestern Nevada,

the Red Desert of southwestern Wyoming, and in the Pryor Mountain region of Montana. Other island ponies include those on Sable Island, an isolated sand island about one hundred miles off the coast of Nova Scotia, in the North Atlantic, and on Shackleford Island, a small barrier island off the coast of North Carolina that is part of Cape Lookout National Seashore.

Most historians believe that the original Assateague animals were solid in color and horselike in size (over fourteen hands two inches or fifty-eight inches at the withers), but that their characteristics were altered over the years both by nature and by man. The Baltimore Maritime Museum has in its collection a nineteeth-century document telling how, in 1820, a Spanish ship, *San Lorenzo*, carrying ninety-five small, blinded ponies back to Spain from work in New World mines wrecked off Assateague, Maryland. The survivors of this wreck may have bred with animals already present on the island causing a decrease in size. However, park historians discount the *San Lorenzo* account.

The small size of the ponies may also derive from poor diet. Analysis of the plants that are most often eaten by the ponies indicates that in winter this diet lacks sufficient protein to provide proper growth and maintenance. Some ponies removed from Assateague as foals and fed a higher protein diet grow to horse size. Ponies remaining on the island diet rarely reach thirteen hands (fifty-two inches). Some scientists speculate that the ponies' reduced size and compact body build are traits selected for a windswept, sparsely vegetated island that experiences extremes of temperature.

For much of their existence, the ponies on Assateague were owned by private citizens who brought new stock to the island and sold or removed desired animals to the mainland. The first pony penning, forerunner of the famous annual pony penning on Chincoteague, may have begun in the late 1700s. The initial reason for penning seemed to be branding, to establish ownership of unbranded animals. Some animals were taken off the island for use in agriculture or transportation and others brought back.

The solid colors of the original ponies changed to the present piebald or pinto pattern as the apparent result of Shetland ponies interbreeding in the early 1900s.

Manipulation of the pony population has been the pattern for many years, but that pattern has been altered since Assateague Island

became a National Seashore in 1965. All privately owned ponies were removed, and the Berlin, Maryland, Jaycees donated twenty-one Assateague ponies, nine males and twelve female ponies, to the National Park Service to form the nucleus of a permanent herd to remain on the Maryland portion of the island. This Park Service herd has not been manipulated and is completely free to range over all parts of Maryland Assateague. A wire fence prevents mixing of the Maryland herd with animals living on Virginia's portion of Assateague.

The Chincoteague, Virginia, Volunteer Fire Company owns the Virginia herd which it grazes on lands administered by the Chincoteague National Wildlife Refuge and which it limits to a maximum of 150 animals. Unlike the Maryland ponies, the Virginia herd is closely managed. Fences limit movement, blocking the ponies from reaching the dunes and beach along most of Virginia Assateague. Foals and an

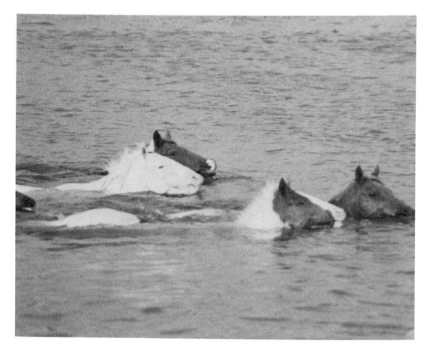

Cotton (white pony) and Bertha (brown and white pony) and other ponies during swim between Assateague and Chincoteague for the annual auction sponsored by the Chincoteague, Virginia, Volunteer Fire Company each summer.

occasional yearling are removed by the annual pony penning, while animals are added from a variety of sources. A restaurateur from Ohio donated two Spanish Barb stallions for breeding to the Fire Company. These show buckskin coloration and mustang conformations, traits similar to those of Spanish Andalusian horses. Foals sired by these stallions are highly prized and may bring over one thousand dollars at the annual pony auction.

An important management problem arose in 1975 when almost half of the Virginia herd tested positive to the Coggins test for equine infectious anemia (EIA or swamp fever). The infected ponies showed no intention of dying or even becoming seriously debilitated, but EIA is a reportable disease and according to Virginia law, infected animals must be quarantined or destroyed. The prospect of putting away these animals, with their sentimental value for thousands of children and adults, was not an attractive one. For three years the infected ponies were quarantined in one section of the island, separated by several miles from the healthy animals. They produced large numbers of foals in those years; almost all proved to be free of EIA and could be sold at the auction. In 1978, however, the infected ponies were destroyed to make room for forty mustangs that the Fire Company brought to Assateague from a Bureau of Land Management "adoption center" in California. While vegetation is more plentiful on Assateague than on western ranges, it is less nutritious. This lower quality food plus the brackish water and fierce biting flies caused most of these new arrivals to perish the first year. The female survivors have been incorporated into several of the original pony bands and have produced foals, while two mustang stallions formed new harems. The long-term ecological and political effects of this introduction are still to be determined.

The National Park Service, on the other hand, regards disease as a natural environmental factor. Since the Maryland ponies are not rounded up or sold and live essentially in quarantine, they are not routinely tested. The ponies that have been checked showed no evidence of the disease.

The ponies make good subjects, and Assateague lends itself to behavioral research. The narrow island's flat, open terrain makes it easy to locate pony bands and to make observations both day and night. Exposure to thousands of visitors each year has acclimated the herds to the presence of humans. Most of the ponies can be approached within ten to twenty feet, and some will even look for a

handout. Because of sex, size, color, and marking variations, almost every pony can be individually identified.

Some visitors are disappointed that these so-called wild ponies do not run away from them, but these ponies are "wild" only in the sense that they are free to roam as they please, to forage their own food and water, and to live and reproduce as they choose.

The basic study technique is to pick a pony band, go into the field, follow it over a period of time, and record on data sheets what each band member does. Band locations are noted on maps. Some of the bands on the more remote portions of the island stop grazing and stare when approached. But once the animals recognize the researcher as just another boring human being, rather than a possibly more interesting pony, they return to normal activities. The observer becomes virtually a member of the band.

In some cases, reaching or staying with a band is difficult. Bands often graze on small marsh islands in the bay south of Tingles Island. Getting there requires a twenty-minute walk through waist-deep water, refreshing on a hot summer day but chilling at other times.

Because these wild ponies, unlike most others, are not upset by the presence of human observers, nocturnal observation is feasible. Just by listening, it is possible to determine if an animal is feeding or resting, so that a record of their nocturnal activity patterns can be made. Darkness seems to have no effect on the behavior of the ponies. Sometimes the entire band would run off through the bushes in a rush to a waterhole and leave the observer lost in the dark.

To collect data on individual animals over time, each pony had to be given an identity. Each pony was photographed and its specific color and markings recorded on an identification sheet showing left- and right-side views as well as drawings of the front and back ends. Each band was assigned a letter and each pony in the band a number. Foals received their mother's designation plus a letter indicating the year of birth (A for 1976, B for 1977, C for 1978, and so on), thus making it easier to recognize relationships. Foal N_2B-E-H has a rather clumsy name to remember, but one that provides the researcher with the identity of the mother (N_2B-E, a foal of N_2B born in 1980), grandmother (N_2B, a foal of N_2 (born in 1977), and great-grandmother (N_2) of the foal as well as the year of birth (H being 1983).

As in other behavioral studies, some ponies earned conventional names related to their appearance, personality, or family life. A young male, for example, became Comma because of the shape of the white

flash on his chestnut face, while an old pinto mare was dubbed Nasty because of her aggressiveness. One elderly mare was named Irene because, like a grandmother of the observer, she produced three females then one male offspring.

2.

Maintenance Behaviors

MAINTENANCE behaviors are those activities which keep an animal in good condition throughout the year. They take up most of the time in each day and include feeding, drinking, resting, grooming, and eliminating body wastes.

All free ranging horses, including the Assateague ponies, graze, grinding up vegetation with highly specialized, elaborately ridged premolar and molar teeth. Almost eighty percent of the annual diet is grass, the most important being saltmarsh cordgrass. As the name suggests, this plant is salty, very fibrous, and highly abrasive; yet it alone comprises more than half of the ponies' food. Saltmarsh cordgrass grows in the extensive salt marshes lining the western edge of Assateague and occasionally in other areas periodically inundated by salt water. The second most important grass, making up about twenty percent of the annual diet, is American beach grass. A pioneer plant, beach grass invades areas of bare sand and is the major vegetation on the primary and secondary dunes along the ocean. Other important grasses are the American three-square rush and the giant reed phragmites, plants that grow in low areas where fresh water accumulates, as well as salt-meadow hay, that grows in the higher, drier portions of the marsh.

In addition to grasses, the ponies enjoy poison ivy, downing it with no apparent ill effect. Also, their flexible but tough lips enable them to munch on prickly greenbriar stems pulled from loblolly pine thickets and soft green sandbur thorn balls growing among clusters of dune grass. When winter limits grazing and the remaining vegetation loses much of its texture and nutritive value, the ponies become

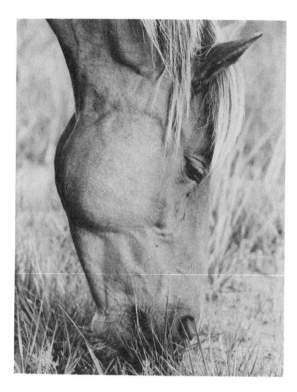

A pony grazes on its favorite food—saltmarsh cordgrass.

browsers, chewing poison ivy stems and those of the spindly marsh elder shrubs in the higher salt marshes and the bayberry behind the dunes.

And Assateague ponies are opportunists. When strong winter storms toss masses of bright green sea lettuce onto the salt marshes, entire bands of ponies compete for this rather exotic food item. Nutritional analysis provides an explanation: the seaweed contains more than twenty-five percent protein, whereas the dead, decomposing marsh grasses of late winter contain less than nine percent. The ponies feed on the hips of the beach rose and on the crab apples from ornamental trees planted by earlier Assateague inhabitants. Using their front teeth, they strip nutritious seeds off the large seed heads of dune and poverty grass and use their hooves to expose the tender underground stems of other grasses. When an occasional snow blankets the island, the ponies will scrape the snow away with their hooves or push it with their noses to expose the grasses below.

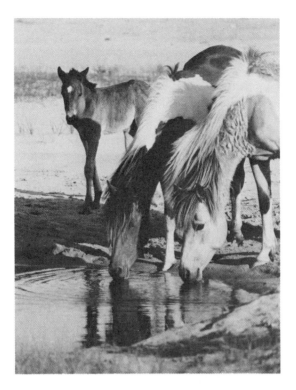

Ponies Marianne and Irene drink from a typical water hole. Note that the foal is not drinking. It gets its fluid from nursing and does not need the water.

Salt water surrounds Assateague, but the ponies drink very little of it. When they do drink from the ocean or bay, they have been standing in the hot summer sun or have been exerting themselves for a long period. A drink consists of a few short sips lasting less than ten seconds.

Ponies prefer fresh water, or at least water that is very low in salt. Fresh water is found in water holes located on the higher center portions of the island. Some of these water holes or depressions are temporarily filled with rainwater, and may dry up completely in periods of drought. Fortunately, there are permanent freshwater holes supplied by rainwater and by underground seepage. Some of these extend more than twenty feet in diameter and are three-to-four-feet deep. Most are hidden among tall grasses or sheltered among trees and shrubs, but the ponies move to them unerringly after walks as long as fifteen to twenty minutes.

Movement to water holes occurs most commonly just after dark and just before sunrise. On hot summer days, pony bands may also move to water near midday. Getting to the water hole is a very obvious activity. One animal in the band begins to move toward it, and the others quickly follow. The members of the band move in single file until near the water hole. Then, they all run to it. After drinking, they remain around the hole, resume feeding, rest, or trail slowly back to the marsh.

In contrast to their drinking behavior at salt water, ponies take deep, long draughts of fresh water lasting one-to-three minutes. Another sip or two may run the total drinking time to five minutes. In winter ice often covers the water hole. If the ice is thin, the ponies break it with their hooves. When the ice is too thick, they move to places where water drains into the hole. Here the ice thins and can be broken.

Because they consume so much salty food, the Assateague ponies have a serious salt removal problem. They apparently deal with it by drinking twice as much water a day—flushing the excess salt from their bodies—as their domestic counterparts.

Ponies most commonly rest in a standing position, supported by three legs while resting the fourth. The animal locks its bones in place, then relaxes its muscles. The head hangs below the horizontal part of the body, the ears turn laterally toward the outside, and the eyes close. In deep sleep, the lower lip droops. The pony sleeps for as long as sixty to ninety minutes before awakening with several wide yawns.

Often after resting on its feet for a while, the pony buckles its legs and drops heavily to the ground. Initially lying on its breastbone (sternal recumbency) with legs tucked beneath, the pony may roll to its side and lie with legs extended straight out (lateral recumbency).

Lying down seems more restful to the pony than standing, but scientists have determined that it is more expensive from an energy standpoint and interferes with breathing and circulation. Getting up from the recumbency position is also a demanding process. The pony straightens out its front legs, shifts its weight to the hind legs, and pulls itself up.

The type of resting behavior found varies seasonally and with age. In summer the biting insects and heat prevent adult ponies from lying down during most of the day. The ponies sleep in sternal or lateral recumbency only during the hours of darkness and in the

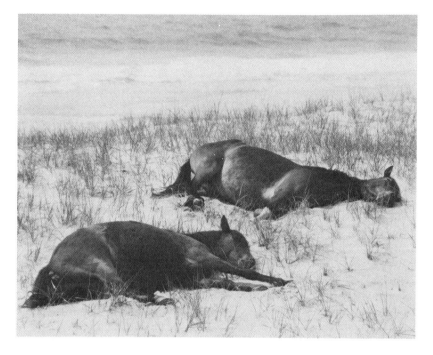

The lateral recumbency resting position.

hours right after sunrise. Younger ponies seem more tolerant and will lie down throughout the day. In winter resting occurs less frequently than in summer, because more, lower quality food must be consumed, and it is concentrated around midday when temperatures are the highest.

Grooming maintains the quality of the coat, and consists of auto- or self-grooming actions, where the animal itself performs the actions, and/or mutual grooming, where two or more ponies join in simultaneous grooming. The most common form of autogrooming is simply rubbing behavior, where a pony rubs some part of its body against such inanimate objects as a tree trunk, branch, or fence post. When rubbing, a pony often looks like it is performing some sort of dance, shifting its weight from one side to the other as it scratches its back against something. Ponies also ease their itches by nibbling at annoying areas with their large front teeth. This biting is loud and can be heard twenty feet away.

Rolling is a second form of autogrooming. The ponies lie down sternally and then roll from their side to their back and over to the

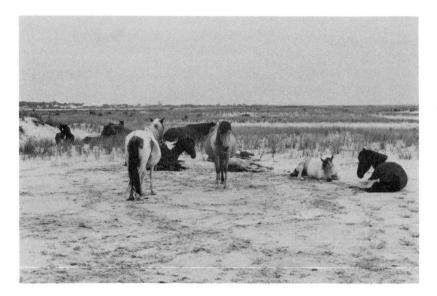

The contagious nature of resting behavior—all members of M band standing or in sternal or lateral recumbency.

other side, usually completing two to three rolls before getting back on their feet. Rolling serves several functions. It chases biting insects off parts of the body not easily reached by tail or mouth and helps dry the coat after rain or a walk through water. Like resting or movement to water, rolling is an example of *contagious* behavior. An action by one pony triggers similar action in other ponies until that behavior spreads through the entire group. (Yawning in humans is also contagious; the sight of someone yawning increases the probability that others will yawn. Scientists call this contagious spreading of a behavior *social facilitation.*)

Perhaps more interesting than autogrooming is mutual grooming. At one time scientists considered mutual grooming only a way of getting out-of-reach itches scratched—get a friend to do it and return the favor. Today it seems more significant. Mutual grooming also serves an important social function; it establishes and maintains social ties. Not surprisingly, therefore, mutual grooming is often initiated by a subordinate animal for a more dominant one. Most mutual-grooming partners, however, are either close relatives (mother-foal or two siblings) or unrelated animals similar in age or social rank.

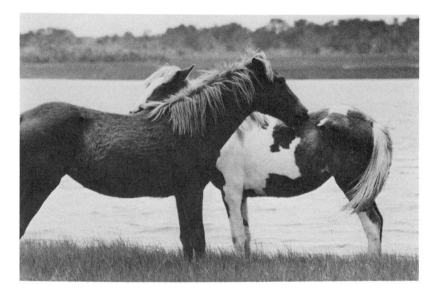

An example of mutual-grooming which serves a maintenance and social function for the animals involved.

Most mutual-grooming actions are directed at the withers (the hump at the base of the neck) but may also include the neck, chest, back, and rear and last for several minutes. After a pause, they usually start again on the other side.

Eliminative behaviors include urination and defecation. While important because they remove harmful metabolic wastes and undigested food, these behaviors are also significant in other contexts. The urination posture of males differs markedly from that of females. Females urinate by spreading the back legs and raising the tail. Male ponies take a quick step forward and crouch so that the back legs are not straight, as in females, but lean at about a forty-five degree angle from the ground. This difference in posture is shown even by foals and makes a reliable sex indicator. Female urination increases in frequency during estrus and just before foaling, providing an indicator of these events. Males urinate more frequently than females because they use urine to mark the eliminations of other ponies. Males also use defecation to mark, and to play a role in male-versus-male aggressive encounters. (These special functions of eliminative behaviors are discussed in more detail in Chapters 5, 6, and 8.)

3.

Activity Patterns

A ssateague ponies spend about seventy-eight percent of the daylight hours grazing and about nineteen percent resting. At night, they spend about fifty-four percent of their time grazing and about forty percent resting. These activities follow a definite rhythm or pattern, with periods of intense grazing alternating with periods of rest. All of the other behaviors occur at low frequencies, averaging less than one minute out of each hour, with no particular daily pattern.

Ponies graze most intensely after sunrise and in the late afternoon. As the day progresses, grazing decreases and resting increases, the latter peaking from eight to eleven in the morning and from two to four in the afternoon. With the onset of darkness, the ponies move to water (walking and drinking activity becomes significantly greater in the first hour of darkness than in any other hour) and graze heavily. As the night progresses, grazing decreases, and they rest more. This transition often entails movement from marsh feeding areas to resting sites on "islands" (really elevated sand areas scattered through the marsh and large enough to support stands of pine and oak), or on the primary dunes overlooking the ocean, and on the beach. Of the two resting modes, standing is more common between ten and twelve at night. Ponies rarely lie down in early evening. They do later, and this mode peaks between one and three in the morning. Just before sunrise, intensive grazing begins, consuming more than fifty-two minutes out of the hour, and the bands will seek water. They tend to drink three times a day (early morning, near midday, and late afternoon) in summer, twice (sunrise and sunset) in winter. Grazing

frequency increases during the winter at all hours, probably because of the lower nutritive value of the food and the animals' higher metabolic rate. The resting mode also varies seasonally. In summer, ponies graze less and stand more—partly because of the higher quality food and partly because of the harassment of biting insects which drive the ponies to stand on the mud flats, the beach, or in the bay. In winter, ponies generally lie down only during the middle of the day when the sun warms the ground.

Auto- and mutual grooming occurs more frequently April through June than it does through the balance of the year, possibly because of the ponies' need to shed their thick winter coat for one more suitable to the summer. Mutual grooming also reduces aggression and promotes courtship.

Utilization of habitats also varies between summer and winter. In summer, the Maryland ponies prefer the salt marshes, spending forty percent of their time there. They spend twenty-three percent of their time in the primary and secondary dunes, and twenty-two percent in the grassy areas behind these dunes. To a lesser extent, they use the beach (nine percent), the bay (four percent), and the mud flats (two percent)—the latter, as noted, to avoid biting insects. In winter, they tend to move from the marsh and make greater use of the dunes and inner dune areas. They never stand on the beach or in the bay. Most dune grazing takes place behind the sand mounds, which protect the ponies from the strong winter winds. Indeed, these winds, plus the deteriorating vegetation, may encourage the bands to move from the marsh. When resting, pony bands stand on the leeward side of the shrubs, using them as windbreaks.

The use of fences in Virginia restricts the movement of southern ponies and results in different patterns of habitat utilization than those of the northern ponies in Maryland. The southern bands spend more than eighty percent of their time in the marsh throughout the year, and are prevented from grazing on the dunes and using the beach as an insect refuge site. Such a pattern of habitat utilization is probably atypical, since the one southern pony band that lives outside the fencing on the "hook" of Assateague shows a pattern similar to that of the free ranging northern bands.

Many factors appear to regulate movement of the pony bands: habitat, season, time of day, and band size. Bands move at a more rapid rate on the primary and secondary dunes than they do on the inner dunes or in the marsh, apparently because the vegetation there

is sparser. To obtain the same amount of food, the ponies have to cover more ground. Because of smaller home ranges and a different pattern of habitat utilization, the southern Virginia bands display less daily movement than the northern Maryland bands.

Seasonally, the ponies move faster in summer (about 5 kilometers or 3.1 miles per hour) than in winter (about .2 kilometers or .12 miles per hour). Several factors contribute to this: summer harassment by biting insects and subsequent long-distance walks to refuge sites on the beach, mud flats, or bay, more frequent trips in summer to water, and the tendency, in winter, for bands to concentrate on smaller, protected areas. Movement also varies by time of day. Bands move more in early mornings than in the afternoon or early evening during summer, and movement drops greatly at night. This pattern correlates with the ponies' pattern of using the dunes, grazing more rapidly in the morning, and moving to the marshes or insect-refuge sites, with slower movement or standing, in the afternoons. Winter observations found increased movement from eight to ten in the morning and from three in the afternoon to eight in the evening when the ponies are grazing on the dunes, and less movement during the major rest period at midday.

Lastly, the rate of movement seems to vary inversely with the size of the band. Larger bands move more slowly, between .2 and .49 kilometers an hour (or .1 and .3 miles an hour), than do smaller bands, who range between .24 and .88 kilometers an hour (or .15 and .55 miles an hour). The greater complexity a large band encounters in movement synchronization probably accounts for this difference.

4.
Interactions with
Other Animals

THE Assateague ponies do not live in a vacuum and interact with a variety of other creatures. Two kinds of deer, the familiar white-tailed and the exotic sika, inhabit the island. Sikas, native to the Far East, belong to the elk family and were brought to the island by the Boy Scouts in the 1920s. Currently they outnumber white-tails there four to one. Though both are herbivores (plant eating), neither really competes with the ponies for food. While ponies graze mostly on grasses, deer diet on less than ten percent of the grasses. Some competition may occur in late winter when all three groups of animals nibble on poison ivy and bayberry stems. Even this competition is only indirect; ponies seek the plants by day, deer by night, and this common food period lasts less than a month. Sika bucks roam easily through grazing pony bands, stop to rub velvet from their antlers on marsh shrubbery, and each group ignores the other.

The carnivorous red fox, however, feeding on flesh, often scavenges pony carcasses. Since they weigh less than twenty pounds, foxes present little danger to healthy foals and fawns, and they frequently pass unheeded through grazing pony bands.

Assateague also houses many aquatic and land-dwelling birds, but most do not interact with the ponies. In summer, brown-headed cowbirds feed at the feet of grazing ponies while red-winged blackbirds feed by strutting up and down the pony necks seeking the insects hiding in their manes. In fall, starlings replace them, perching on the woolly ponies, preening feathers, watching for predators from this elevated platform, and feeding on the inevitable lice. But the

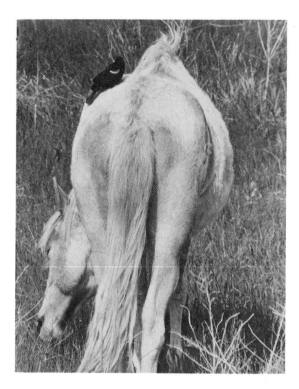

A red-winged blackbird riding on the back of Cottonelle, daughter of Cotton.

truest interactor, almost in partnership with the ponies, are the cattle egrets.

However indifferent they may be to deer, foxes, and the feeding birds, there remain certain other Assateague dwellers the ponies just cannot ignore: the abundant, relentless ticks and insects. From April to August, ticks wait in the underbrush and apply themselves to any passing warm-blooded animal. Pony watchers can pick up from twenty to thirty ticks in a half-hour observation, and it's rare to find ponies without blood-engorged ticks clinging somewhere on their bodies. They can be spotted easily on the bare skin of the anal area and in the thin hair around the face. Despite the blood sucking, ticks seem not to create much bother, and ponies occasionally stand patiently while visitors pluck off the ticks with clamshells. The National Park Service does not encourage this bit of courtesy, since tourists may be kicked or bitten by an unpredictable animal. Mosquitoes swarm over the island and often these insects cover the ponies' undersides trying

to extract blood through the thick skin. They, too, are largely ignored, except when ponies graze in the marsh. The ponies inhale mosquitoes then forcefully blow them out from the nasal and respiratory passages.

A greater nuisance are the biting flies. Biting flies not only hurt, but they often create open sores which fester, and can transmit such diseases as equine infectious anemia and equine encephalitis. Furthermore, biting flies generally disturb the ponies foraging and resting. These biting flies, three varieties of greenheads, deer flies, and stable flies, reach their greatest population density on the island in July and August. Their harassment over the three hundred years the ponies have shared the island with them has led to special insect-avoidance behaviors, which are really redirected normal grooming actions: foot stamping, biting, or snapping at insects within range, and rubbing against trees or other solid objects. Entire bands will leave the marsh to walk, twitchily, through thick brush which scrapes off the parasites.

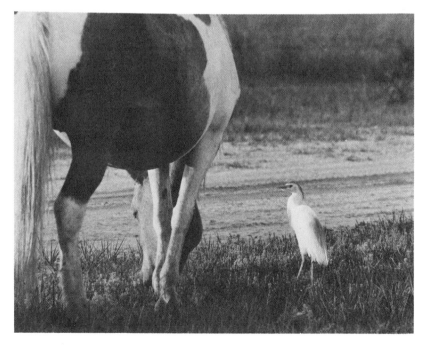

A cattle egret waits for insects at the feet of Nadia.

Help comes in the form of the cattle egret, a heronlike, long-legged, tall, thin bird with a long, pointed bill. Cattle egrets originated in Africa where they're often pictured on virtually every large mammal. Somehow they migrated to South America in the late 1800s, crossed the Caribbean to Florida by 1942, and were first spotted on Assateague in 1956.

Cattle egrets stand on the backs of the ponies and walk around in the vegetation at their feet. This association can last for an hour, and involve up to twenty birds. When on the backs of the ponies, the egrets preen and rest, rather than feed. Birds on the ground, near the ponies, strike at insects, like grasshoppers, four times more often than birds feeding alone. The ponies assist the egrets by flushing up hidden insects. Observation indicates that seventy percent of the egrets' "pony-time" diet consists of insects stirred up by the ponies, while the remaining thirty percent of the diet comes from the biting flies, ticks, and lice picked off the bodies of the ponies. The ponies and cattle egrets live in a symbiotic relationship wherein both species benefit from their association. The egret gets help in feeding from the pony, and the pony is relieved of its annoying parasites.

When the insects become unendurable, ponies race to "refuge" spots, where the vegetation is sparse and the wind velocity is higher,

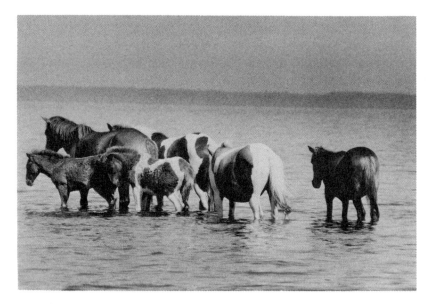

N band wades into Chincoteague Bay to escape the biting flies.

because the insects are fewer there. Pony bands remain in these safe places for as long as ten hours at a time during the hot summer months.

One important insect refuge is the shallow water of Chincoteague Bay on the western side of Assateague. Ponies walk as long as fifteen minutes into the bay, moving as far as a half mile or more from shore. Why they choose to stop at a particular place in the bay is unknown. It's thought that they choose a spot sufficiently far from shore to outdistance the flies but not too deep for the foals to stand and nurse. They do not roll in the water but occasionally take a sip of water or slap wet tails against their sides to keep their coats a little damp and, thus, cooler in the summer heat.

In addition to standing in the calm waters of the bay, the ponies walk out into the ocean surf. This usually follows long periods of standing on the beach in the hot summer heat. One pony generally starts into the water, and the band follows, reaching a chosen spot before turning so that the surf breaks over their backs. It's a spectacular sight, and they remain only a few minutes—no more than twenty. The foals usually hesitate, but a few older, larger ones will venture out with their mothers.

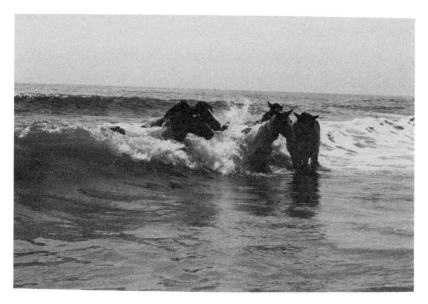

L band in the surf to get away from the biting flies.

When they emerge from this quasi-shower, they roll in the sand or beach vegetation to dry their coats. Their wet coats do not pick up a covering of sand as the wet skin of a human being does. Foals dash about in quick bursts of energy, then follow the band back to the business of grazing.

Unlike domestic horses, the Assateague ponies rarely use the shade provided by trees as an insect refuge. The dense vegetation of the forested areas support populations of hungry deer flies and have few cooling breezes. Instead the ponies stand in the hot sun on open mud flats or in asphalt parking lots, moving slowly from one spot to another seeking locations where biting insects are fewer.

Some bands make use of a manmade insect refuge site; they stand under the cement bathhouses in the Maryland State Park camping area. Not all of these structures are far enough off the ground to allow the ponies to squeeze beneath them, but the ponies seek out those that are and spend hot afternoons there. The campgrounds not only provide shade; they are sprayed daily with insecticide, and so they contain fewer biting insects.

5.
Social Organization

UNLIKE domestic horses who often live out solitary lives, the feral ponies of Assateague have companions in stable social groups known as bands. Most of the bands are family or harem bands consisting of a stallion, one to sixteen adult mares, and their offspring ranging to about three years of age. Other bands include bachelor groups of two to four young males, or mixed groups of young males and females. These groups often contain animals that have dispersed from the same band and are related through the same father. Bands consisting of mares and their offspring occur when the harem stallion dies, but these bands tend to last only a few months before a new stallion assumes control. Finally, a few solitary ponies can be found, but they are either young animals recently dispersed from their natal bands or older "free spirits" who wander in and out of harem bands.

The size of the typical harem band on Assateague and the number of sexually mature mares in each band has varied over the years, and this variation has been inversely related to the number of bands. The 45 ponies present on the Maryland portion of Assateague in 1975 were organized into three harem bands (M, N, and T) and one bachelor band. The harem bands averaged 14 ponies, and each band contained six (5.7) mares. By 1984 the number of harem bands on Maryland Assateague had increased to 10 but average band size had dropped to just over 9 ponies per band. Likewise, the number of sexually mature mares per band had decreased to 3.8, suggesting there was stronger competition among stallions for mares. Bachelor bands also increased in number from 1 band in 1975 to 3 bands in

A typical harem band (T band) composed of one stallion—the horse on the
extreme left biting flies—mares, and their offspring.

1984, but average band size remained constant at approximately 3
animals.

The size of harem bands on the southern (Virginia) portion of
Assateague is larger, averaging about twenty ponies per band. These
large harems result because the number of sexually mature males,
and therefore the competition for mares, is greatly reduced because of
the sale of colts at the annual auction.

Harem bands are held together by social ties between individuals
rather than by the action of the harem stallion. The band persists
even when the stallion wanders off or dies. In order for the band to
remain together, aggression among its members must be controlled.
To reduce aggression band members accept a pecking order or hier-
archy in which each animal knows its place. High ranking ponies
have first access to drinking water and such limited food resources as
seaweed or "people food" from campers' ice chests and garbage cans.
Lower ranking animals concede rather than fight.

Several factors influence position in the hierarchy. Age appears
most important, with older animals dominant over younger. Disposi-
tion or temperament comes next. Some ponies are more belligerent

than others. Heredity also has influence: the daughters of dominant mares often hold higher status, while the offspring of low ranking mares stand near the bottom of the hierarchy. Size and sex, however, do not seem important, and though the harem band contains only one adult male, he is not always dominant.

Although a dominance system reduces aggression in the long run, some initial aggression is needed to establish the hierarchical order. Once each animal takes its place, aggressive interaction is rare, occurring at frequencies of one to two per hour. Most of these aggressions result from the invasion of one animal's personal space by another.

Aggressive behavior to maintain status within a band falls into five categories. The lowest form is displacement. Here a high ranking animal simply takes over the space occupied by one ranked lower. If the lower ranking pony fails to move, a higher form of aggressive behavior, a threat, occurs. This threat is really a threat to bite. Ears lie back tight against the head (reflecting the increased state of anxiety), and the mouth turns toward the subject of the aggression. Lips cover the teeth initially, but if this threat proves ineffective, the aggressor bares its teeth, opens its mouth, and bites at its victim. Threats are common when a mare nurses her offspring. Apparently feeling vulnerable in the nursing posture, the mare "clears out" a space around her by threatening other animals.

The two highest forms of aggression are the threat to back-kick and the actual back-kick. In threatening to back-kick, the pony shifts its hindquarters toward an opponent and beats its tail back and forth like a metronome. The aggressor backs toward the opponent. If the opponent does not back off, the aggressor raise its tail, lifts its legs off the ground, and extends both in a full two-legged kick. Though most of these dangerous blows miss their mark, they sometimes thump directly onto the chest or flanks of an opponent. The receiver of the kick rarely flinches and may even retaliate with a back-kick of its own.

Because the high cost of aggression (risk of injury, increased expenditure of energy, and interruption of normal behavior patterns) increases as the intensity of aggressive behavior increases, more than seventy percent of all aggressions are low-cost displacements, threats, or bites. Low-cost actions occur when the two animals involved differ in dominance rank. However, if two ponies of similar

rank quarrel, they must employ more intense, high-cost tactics like back-kicks. Highly intense encounters are often accompanied by loud, high-pitched squeals.

When a band of ponies grazes, no one animal influences the direction of movement. Instead, the band members wander aimlessly across the marsh, but when the band moves to water holes or to insect-refuge sites, a definite leader emerges. Although the leader tends to be an older mare, leadership is not directly related to dominance. An old mare may have a number of offspring in the band who respond to her actions. When she moves toward the waterhole, her offspring look up and begin to follow. The movement of these animals influences other ponies to follow and, soon, the entire band stretches out in a straight line behind the leader. The stallion is often the last animal in line. Some scientists believe this rear-guard position allows the male to defend his harem against an approaching predator or another stallion, but this may come about because the stallion is often widely separated from the mares, and is simply left behind.

In some situations the stallion may act as leader. Norris, the stallion of N band, consistently leads the band when it moves from grazing sites on the dunes across the island to insect-refuge sites in the bay and on mud flats along the bay, but he rarely leads the band to water.

Each pony band restricts its movements to a specific geographic portion of the environment known as the home range. It is the area covered during day-to-day activities, and on Assateague the home range varies in size from 2.2 to 11.4 square kilometers. Home range size does not correlate with group size but rather with resources available. Bands with dense supplies of forage have smaller home ranges than bands living where the forage is less dense. Several bands may share such resources as a water hole so that some home ranges may overlap. The boundaries of these ranges are not defended and cannot be defined as territories in the classic sense.

There is a considerable difference in the size of the home ranges of harem bands on the Maryland and Virginia portions of Assateague. Average home range size for northern bands is 6.48 square kilometers (or 2.5 square miles) while home range size for southern bands averages only 1.72 square kilometers (or .66 square miles). Futhermore, there is almost no overlap of home ranges for northern bands, while there is considerable overlap in the home ranges of southern bands.

This overlap results because some bands are restricted by fencing to the same 3.2-square-kilometer or 1.23-square-mile area, known as Black Duck Drain, south of Beach Road in the Chincoteague National Wildlife Refuge. Five other bands are kept by barbed wire fences in a 5-square-kilometer or .19-square-mile area of the refuge known as the Wash Flats. The movements of northern bands are not restricted by fencing, so that they are distributed widely over the total available acreage.

Stud piles are prominent features in the home ranges of many pony bands. They consist of accumulated fecal matter and often reach considerable size (up to six feet long and two feet high). Only the stallion contributes to stud piles, and he seems to do so every time he passes a pile. Since the piles occur randomly rather than at home range boundaries, they probably are not warnings to keep away other bands. But they do indicate how recently a stallion has passed.

Harem stallions also mark the urine and feces of their mares with their own urine. The male sniffs the mare's urine or feces, takes a quick step forward so that he strides the material, and sprays a quantity of urine over it. This marking may mask the odor of the mare with the scent of the stallion, or it may indicate that the mare belongs to that stallion.

6.

Threats to the Harem Stallion

A HAREM stallion exercises exclusive rights to the mares in his band, and the size of his harem and the duration of his control over his harem is a measure of his success. He must continually work to prevent his mares from leaving the harem, to protect them from marauding stallions, and to drive young male offspring out of the band when they become a threat to him.

The stallion controls his mares by driving or herding them with a series of characteristic posturings: pressing his ears tightly to the head, fully extending his neck, and dropping his head close to the ground, often swinging it from side to side to accentuate the display. The mares move and the young follow, herded sometimes by the stallion if they stray. If the band moves too slowly, the stallion will bite out at the mares, nipping their necks, flanks, or hindquarters relentlessly even when they slip in the marshland mud or fall and struggle to get up. He may show great urgency, even if the move is a peaceful one, but often he can round up mares who wander too far or draw too near another band simply by dropping his ears and head and walking toward them.

If a predator attacks the band or another stallion attempts to raid the mares, the harem stallion will move between the mares and the attacker and drive the band full gallop. Raids are common as competing stallions seek to increase their harems or to start one.

These confrontations between stallions differ from those used to establish and/or maintain dominance. The actions are highly stereotypic and recurrent. The stallions, some distance apart, stand and stare at each other. Each defecates, smells the fecal pile, then stares

Mort drives or herds Irene, her foal Russ, and her yearling Joan back to M band.

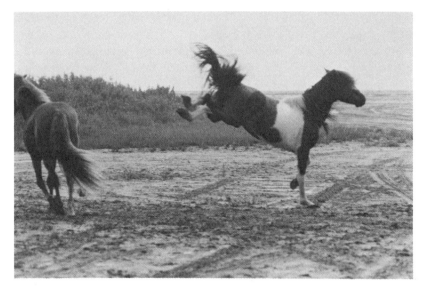

An example of the back-kick. Bobby delivers back-kicks at Norris during a fight.

again. If the intruder remains, they move toward each other, necks arched and tails high. Legs pound the ground in a high stepping, exaggerated trot called a *parallel prance*. This ritualized action seems to give each animal time to assess the prowess of the other, and if either proves unequal in size or apparent power and experience, the lesser breaks off the challenge by turning away and moving off.

If the two rivals are similar in size and experience, the encounter escalates. Each stallion sniffs the nostrils and muzzle of the other. Olfactory examinations often move to the genital or perianal region and end when the two animals pull apart with high pitched screams. Side by side, they shoulder each other or bite at the neck, head, shoulder, flank, and legs. Many suffer severe bite-wounds that can become infected, eventually causing death. Kicking with one or both forelegs occurs but rarely strikes the opponent. In serious fights the stallions rear instead of biting or kicking, and try to use this increased leverage to knock their opponent off balance.

The fights occur in "rounds" separated by periods of inaction when the opponents back off to graze or rest. The next round of action begins when one male reapproaches the other.

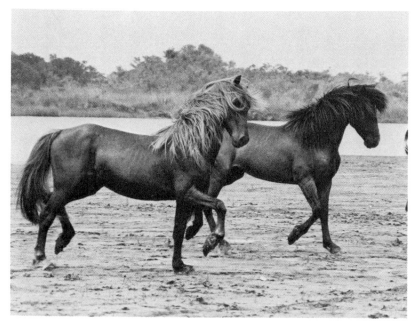

Stallions engaged in the ritual *parallel prance*.

During fights the stallions will often interact at the same fecal pile. Either in unison or in taking turns the males smell the pile, defecate on it, then turn around to smell it again. Although vulnerable to attack in ritualized defecation, the "code of ethics" which governs stallion fights prevents opponents from taking advantage.

Aggressive encounters or fights may last only a few minutes or extend as long as three quarters of an hour. The encounter ends when one of the males moves off on his own or is chased away by the victor.

Harem stallions must also deal with the threat to harem stability posed by young males in the band, most of whom are sons of the harem stallion. The stallion engages in what looks like play behavior with the immature males, biting at their legs and grabbing them by the back of the neck. The young males respond to these attacks by showing a specialized submissive behavior called *champing*. The ears stand straight up, exactly the opposite of where they lie when the animal is aggressive, and the mouth opens with the corners of the mouth drawn back and the lips covering the teeth. The mouth then opens and closes rapidly without the lips and teeth making contact. In addition to shutting off an aggressive attack, champing is also used to prevent an attack. As a stallion approaches, young males move

Bobby sniffs the fecal pile deposited by Norris during an aggressive encounter.

Champing—the submissive posture used by young males to shut off aggression by the harem stallion.

toward him and champ strongly. They often do this right in his face with noses almost touching.

Although young males are the primary champers, immature females may adopt the behavior as well. Most commonly it is done by foals, even yearlings. Older animals never resort to champing but, in submission, tend instead to move away from aggression.

In reality champing really only delays the inevitable. Eventually, the aggression of the harem stallion will drive the young males away. One day they will graze with the natal band; the next day they will graze alone and begin the search for their own harems.

7.

Dispersing the Young and Forming the Band

ALL young males eventually separate from their natal band, but the age of dispersal can vary considerably. Most (fifty-seven percent) leave between their twelfth and twenty-fourth month. A colt whose mother dies or whose older sibling disperses may leave before it is a year old. Others may not leave for almost three years, and one male, a sorrel stallion named Charlie, stayed until he was over four. Charlie was the first foal born into his father's band, and the harem stallion may not have known how to deal effectively with his son.

Some young males disperse on their own accord, wandering off with an older sibling, with a playmate, or simply by themselves. On Assateague, though, most are forced to leave their natal band. As the foal ages and approaches sexual maturity, he becomes increasingly the target of his father's belligerence. The father will harass his son by biting him on the face, neck, and legs, and the harassment eventually causes the youngster to leave. This aggressive treatment meted out by the stallion may result in a large, deep bite on the side of the neck that may become badly infected. Even if the wound heals on the outside, the internal infection can remain, killing the pony. If the pony survives, he may still carry the scar his entire life.

Most young males wind up in a bachelor group. These bands contain two-to-four males from the same natal band (therefore full or half siblings) or from different bands. They occupy home ranges lower in quality and smaller in size than those of harem bands.

Young males in the bachelor groups bide their time, waiting until they are physically ready to challenge the harem stallions. They often play-fight, learning to assess the physical capabilities of future

rivals and practicing skills they will need later. Play fighting resembles in form the serious fighting of adult stallions but is less formalized. It also includes more biting to the face, characteristic of the play fighting of foals. Bachelors also practice other important stallion activity, such as marking and mounting behavior, although the latter is directed at males rather than females.

Some young males do not join a bachelor band, at least not immediately, but wander about the island alone. It may be that they have dispersed from the natal band alone and can find no other young males. Some cross the bay to the mainland. Others cross the fence at the Maryland-Virginia state line, move into the Chincoteague National Wildlife Refuge, and are sold at the annual auction.

About three-quarters of the pony fillies also separate from family bands. Some leave before their first year, but most (seventy-one percent) disperse between their twelfth and twenty-fourth month. This timing probably reflects the onset of sexual maturity as the filly enters her second summer. Fillies wander over the island until they join an already established harem band, or, encountering a bachelor male, begin a new band. But they may remain solitary for up to a year.

Some young females do not leave their natal band but remain there and are bred by their father. It is not clear why some fillies disperse, why others do not, or what causes either behavior. Dispersal may be a means of preventing inbreeding and fostering natural selection. Many females wear the scars of old bite wounds or lack pieces of their ears, suggesting they were forcibly driven from the band. It may be that the harem mares (perhaps even the mother) rather than the stallion force the fillies to disperse.

Mixed-sex (multimale) bands result when several young male and female ponies disperse from the same band and stay together. Ponies from different bands may also combine to form multimale groups. For example, O band formed in 1981 when a three-year-old male and a female from M band joined a solitary female who had dispersed from the same band the previous year. (M band is so designated because most of its home range is on land once owned by the McCabe family. O band gets its name because it is composed of offspring from the M band.) For three years O band remained a multimale band, although the number of ponies in the band varied from three to seven. The composition of the band also changed; the original mares moved on to harem bands and were replaced by three

other fillies that dispersed from M band.

Like bachelor bands, mixed-sex bands are nonreproductive. Even though mating behavior occurs, no foals are ever born. Because many ponies are related, they probably stay together, much as bachelors would, for companionship rather than for sex. Males seem to share responsibilities. For example, when O band was attacked by a harem stallion, first three-year-old Sebastian then four-year-old Russ fought. When a stallion moved toward G band, Gordie fought the invading stallion while Grant herded the mares away from the fight.

Typical one-male harem bands may eventually form from multi-male groups. The young stallions Sebastian and Russ shared control of O band during the summer of 1983, but over the next winter the older male Russ gradually assumed power, driving Sebastian from the band into a bachelor group, so that by the summer of 1984 O band had become a one-male harem band. Similarly G band originally contained three young males—Gordo, Grant, and Garfunkel. For a year they shared control but first Gordo then Grant left to take over bands whose stallions had died. Garfunkel remained as the harem stallion to the two young mares. Apparently males prefer to live and breed with older experienced mares than to consort with younger, sexually inexperienced ones.

One-male harem bands also develop from the actions of bachelor males. In forming new harem bands, bachelors do not act together to harass harem stallions and steal mares, even in bands where the bachelors are brothers. Instead, the dominant bachelor, usually the oldest, begins to follow harem bands or range widely by himself. John, born into M band in 1973, and his brother Bobby, born in 1974, dispersed together from their natal band in the spring of 1976 and lived together in a bachelor group until August of 1977. Then John, acting alone, joined with Virgo, a female born in September of 1975 who recently dispersed from M band, to form J band. Bobby and the other bachelors were aggressively kept away from the mare. Since John and Virgo had spent several months together before John left M band, mutual recognition may have contributed to the attraction between the two animals. Both ponies have the same father, out of different mothers, and so they are half-siblings.

As John acquired more mares and these mares foaled, J band increased in size; from just two ponies in 1977 to six ponies in 1978, to eleven in 1981, and finally, to sixteen animals in 1982. In the spring

of 1983 the bachelor stallion Charlie, John's first son, stole four mares, three with foals, from J band and began a new harem group, C band.

Stealing mares from an already established harem represents a third way young stallions form their own harems. Nikita, a red and white male born in 1979, spent two years in a bachelor group, but in the spring of 1984, he raided the harem band of his father Norris and made off with half the band. Another young male, called the Park Service pony because of the arrowhead-shaped brown patch on his left shoulder, stole three mares from his father's band and formed L band.

Like these other young stallions, Bobby started his band by leaving a bachelor group and following a harem band. He fought several battles with the harem stallion, losing each time but finally separating an older mare with her new foal from the band. Such mares are easier to steal because they tend to isolate themselves from the rest of the band and are less mobile. As Bobby aged his band increased in size through reproduction and acquisition, reaching a peak size of thirteen in 1983 when Bobby was ten years old. Band size seems greatest when the stallion is nine-to-twelve years old, suggesting a male pony reaches his physical peak about this time.

Physical strength is not the only factor important in controlling a harem, however. The summer before he died, the twenty-one-year-old stallion Voodoo fought off the challenges of several other males and maintained a harem of seven mares and their offspring despite his poor physical condition. Voodoo had lost all his lower incisor (biting) teeth—so long before his death that the root spaces in his jaw had healed over—and had great difficulty eating. Apparently the experience of older males allows them to bluff their way through fights and thereby to control their harems until death. On Assateague, no old harem stallion has ever been deposed. Takeover by a young stallion occurs only after the harem master has died—representing a fourth way a stallion may acquire a harem. Thus, the bachelor Khartoum assumed control of T band in 1976 only after its harem stallion Trekkie died after being struck by an automobile. In 1984, when he was eleven years old, Khartoum controlled a harem of twenty-three ponies, the largest harem observed so far on the Maryland portion of Assateague.

8.
Communicatory Behavior

Ponies live in stable social groups in flat, open habitats which enhance communication among them. Not surprisingly, then, they show an elaborate communicatory repertoire making use of acoustical, olfactory, tactile, and visual signals enabling them to communicate details of identity, mood, social status, reproductive state, and present, intended, or likely activity as well as information about the environment.

Ponies create a great variety of noises, and most people are, in one way or another, familiar with these. But this mode of acoustical communication is neither the most common nor the most important. Their noises fall into two categories—vocal (coming from the larynx or voice box) and nonvocal.

Vocal noises communicate more data than nonvocal. Shortest and most highly pitched is the squeal or scream. Consisting of a single, often loud, brief note, it usually denotes the threat of male aggression or of a female's rejection of a stallion's advances. It is sometimes accompanied by a kick or stamping of the forelegs. "Nickers" are low-pitched, "quiet" sounds of varying duration. Feral horses generally nicker in three different contexts. Stallions nicker softly during the courtship exploration of a mare. Mares nicker to call their foals from recumbency, and foals nicker when they approach their mothers after a period of separation. Domestic horses also nicker in anticipation of food. Neighs or whinnies are probably the most familiar vocal sounds. They have the longest duration, carry over the greatest distance, and fall into an intermediate pitch range. Mares whinny when they lose sight of their foals; foals whinny in

search of their mothers. Ponies often respond to the whinny of another, even when out of sight. Evidence suggests that horses can distinguish individual whinnies and nickers. Foals, for example, respond to loudspeaker recordings of their mothers' cries.

Nonvocal sounds stem from a variety of activities: feeding, shaking, coughing, grooming, flatus, and hoof striking, but these seem to have little communicatory intent. Horses also produce snorts and blows, projected by a strong, rapid expulsion of air through the nostrils. Snorts are often incidental, resulting from objects or insects entering the nasal passages. Blowing, however, is often purposeful, signalling alarm as a warning to other band members. And it seems contagious, spreading from one horse to another throughout an entire group.

More vital but less well understood is olfactory—by smell—communication. Effective over distances shorter than acoustical, olfactory communication serves primarily to signal recognition among group members and mares and their foals. Saliva, breath odor, and circumoral glands (glands around the mouth) all offer clues to the sense of smell. Approaching horses investigate noses, flanks, and the perineal region (urinogenital-rectal) where glandular secretions provide not only identity but also reproductive state.

Feces, urine, and birth fluids transmit additional data. Within minutes of birth, the mare sniffs and licks her foal and thereafter rejects any other. Stallions smell fecal "stud" piles and urination spots—especially those of mares in estrus—and frequently display the specialized flehmen, or curled lip, posture, which enhances olfaction. Because stallions mark some stud piles or urination spots and ignore others, each seems identifiable to him. Olfactory communication is clearly more important than acoustical interaction to the ponies, but because of the difficulty investigation presents, scientists have much to learn about it.

Tactile communication entails close physical contact between the animals, and signals pass at point-blank range. They are particularly vital to the mare and foal during nursing. Foals nuzzle their mothers' flanks when they wish to nurse, and the mares guide them to the teats with gentle nudges. And if foals do not maintain pressure against their sides, the mares will move away, leaving the youngsters still hungry.

Touching can also communicate a range of emotions from affection to aggression. As described, adults frequently groom each other.

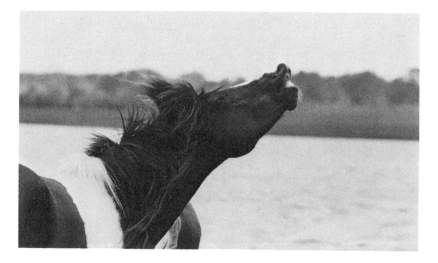

The flehmen—a visual signal that is highly ritualized or stereotypical. It is used during courtship to determine the state of estrus of the female.

One begins by pushing, nudging, or nibbling the coat or mane of another. During rest periods, one pony may lay its head on another in a sign of friendship. The contrast to this, of course, is aggression, which occurs mostly between stallions. Though sometimes reaching the point of kicking, much of this consists of pushing—enabling one pony, perhaps, to judge the strength of his opponent and to determine whether or not he should continue the encounter.

Of all of the signals exchanged between ponies, the visual are probably the most common and important on a day-to-day basis. But they are also the most subtle and difficult for humans to decipher. They involve sometimes marked, sometimes slight changes in posture and in the positioning of the ears, lips, tail, legs, and head.

The displays are often antithetical, which is to say that contrasting messages will be sent in forms directly opposite to each other. Ears tightly laid back on the head signifies a highly aggressive state, while ears tilted forward indicates friendly interest or curiosity. Ears bent to the side shows the animal losing interest or resting. A tail raised above the back means confidence or excitement, as when a stallion approaches a mare for courtship and copulation. A tail tucked against the body means fear and submission.

Some signals last only a few seconds. One pony threatening another may flatten his ears for only a second or two. If the threatened

pony misses the signal, the aggressor may escalate his warning into a bite or kick. Signals of longer duration include the submissive champing shown by young ponies, the driving or herding posture (discussed in Chapter 6), and the deflected tail posture and clitoral winking of mares in estrus described in the following chapter.

Visual signals are also extremely stereotyped or ritualized. They occur in the same fashion repeatedly, probably because they are largely instinctive or inherited behaviors and little influenced by learning or experience. They are complete and correct in form the first time they occur in very young animals. Standardization and ritualization act together to prevent confusion or misinterpretation of visual signals.

9.

Sexual Behavior

THE sexual behavior of the Assateague ponies can be divided into three phases: precopulation or courtship, copulation or mating, and postcopulation. Courtship is a long, elaborate process consisting of a series of stereotyped behaviors. Each behavior serves as a signal, triggering an appropriate behavioral response in the other animal, and each normally must be completed before the process can continue. Courtship is important in reducing aggression between the participants, for a mare usually bites or kicks a stallion who invades her personal space. Courtship also allows the male to determine if the female has reached peak estrus. If not fully receptive, she may become aggressive or move away from the male. In peak estrus, however, she is passive toward him and stands quietly facilitating mounting and intromission.

Precopulatory sequences begin with the male "tending" the female. He remains close to her during grazing and often isolates her from the rest of the band, perhaps to prevent interference during courtship. She provides positive feedback to him by standing in the estrus posture: spreading her hind legs and deflecting her tail to the side. The stallion walks slowly, sometimes rushes toward her, neck arched, ears standing up, and tail raised high over his back. He often whinnies or nickers. Upon reaching her, he sniffs, nibbles, nuzzles, and licks her rump, hindlegs, and flanks, and his penis starts to erect. The mare often turns her head and touches the muzzle of the stallion with her nose. Here, she may squeal and paw the air with a foreleg, or she may break off the courtship by moving away or trying to back-kick. If near full estrus, she will respond with an induced urination,

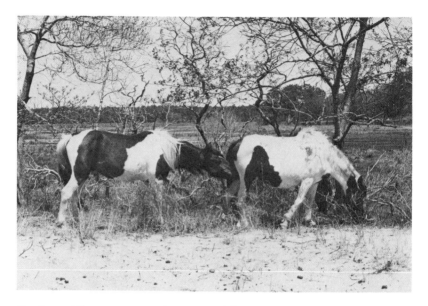

Gordon sniffs at Laverne to determine if she is receptive.

going through the motions of urination but often releasing only a few drops. Induced urination is followed by clitoral winking, where the clitoris is rhythmically everted at a rate of approximately once per second. The red or pink clitoral tissue flashing against the darkly pigmented perineal region creates a strong visual signal visible many feet away.

The male paws the ground with a foreleg then sticks his nose right into the spot of urine, and he may also sniff or lick the urethral opening of the female directly. After several seconds he displays the flehmen, or curled lip, posture. Here the neck extends, the head raises, and the nose tips upward high above the horizontal. The upper lip curls back exposing the upper teeth and gums, and the stallion inhales so deeply, with such force, that the rushing of air can be heard at some distance. Scientists believe this posture forces scent-laden air deep into a special chamber called the vomeronasal organ where sensory cells measure the amount of sex hormones present. After the flehmen, the stallion may repeat the urine-examining procedure, resume nibbling and licking, or mount.

The copulatory stage of sexual behavior is rather brief, lasting from fifteen to thirty seconds. The male rises behind the female on

his hindlegs, holding on to the flanks of the female with his forelegs. Though his head may rest on the withers or back of the female, he does not grasp or bite her to establish a holdfast. Intromission usually occurs, although the male often has trouble penetrating the mare's vulva. A second or third mount may be needed. A few strong pelvic thrusts may follow intromission, but these cease when ejaculation takes place. Following ejaculation the male relaxes, and his head falls briefly onto the back of the female before he dismounts.

Sometimes a male tries to short-circuit the elaborate courtship sequence or mount a nonreceptive mare. He tries to mount even with penis not erect. The mare counters this by running away or by back-kicking. If the stallion mounts, she bites at his head or forelegs or walks forward dragging him after her on his hindlegs. This dragging may continue over many feet of marsh but eventually results in a dismount. Persistent males continue to mount, tire the mare, and eventually achieve intromission.

Specific postcopulatory behavior is virtually nonexistent among the ponies, and this is not surprising since these behaviors in other animals are designed to assure paternity. Such behaviors serve to keep the female from wandering off where other males may copulate with her and displace the sperm of the first male. With the ponies the harem system assures paternity by providing the harem stallion exclusive breeding rights. This opportunity to mate without disturbance is considered basic to the evolution of the harem system of social organization.

Although stallions are ready to mate throughout the year, most sexual activity occurs in the spring and early summer and correlates with the breeding season of the mares. A male may mate with several receptive mares in his harem at the same time, and he may copulate several times a day with an estrus mare. For example, Norris, harem stallion of N band, mounted the mare Nadia seven times in one hour, completing the mating sequence twice. Copulations occur at any time of the day, and may follow grazing or resting.

Other animals sometimes interfere with mating. These may be young stallions, other mares, or the offspring of a mare in estrus. They move between the stallion and mare and prevent them from proceeding through courtship. Young males often try to mount a standing mare from the side while an adult stallion mounts from the rear. Dominant mares consorting with the stallion will chase away young

or subordinate mares who approach. One even mounted a young mare herself.

The sexual behavior of stallions also includes what scientists call masturbatory behavior. When standing at rest they will erect the penis and repeatedly swing it forward against their belly. But ejaculation never occurs. This behavior may serve as a signal or warning to other males, or may perhaps, result from erotic dreams. Males often awake, whinny, and charge over to the nearest mare. Such charges, however, rarely result in a mounting.

Age and experience influence male sexual behavior. Young colts display full penis erection and even mount their mothers, sisters, or other females in the band. Except for flehmen, though, they never proceed to the other stages of the courtship sequence and they never achieve intromission. Colts at play mount other colts, both male and female, suggesting that mounting behavior is inherited. As they grow older, the males will mount only females, suggesting that this later, selective behavior is learned.

Young males also examine the urine of both estrus and nonestrus mares and display flehmen behavior, but do not raise the tip of the nose nearly as high as the mature stallion does. Female ponies, both adult and foal, also show flehmen response to urine and take a posture similar to that of the immature males.

Inexperienced males mount females at first from the front or side in a manner much like the play behavior among young males in a bachelor band. If the mare is in full estrus, she remains still until the male by trial and error, finally mounts her properly. If not in estrus, mares will not tolerate this, biting and kicking the males or moving away. Inexperienced males often fail to penetrate the mare's vulva or take much longer than experienced stallions to achieve intromission. Young mares are more tolerant than older ones, which may explain why young stallions tend to begin harems with young rather than experienced mares.

Unlike colts, fillies show no precocious sexual behavior. When they reach puberty and show their first estrus, they solicit males, presenting their posterior to them and urinating frequently in much the same manner as adult mares. Prior to their first estrus, no behavior they exhibit seems sexual. Rather, it appears to be playful in nature.

Although domestic horse fillies have their first estrus at twelve to eighteen months, no female Assateague pony yearling in her sec-

ond summer has ever displayed the standing, induced urination, or clitoral winking that accompanies estrus. Some females come into estrus during their third summer, when they are twenty-four to twenty-six months of age, but very few conceive at this age and bear foals during their fourth summer. This may be because many pony stallions ignore young mares, because young mares show fear of stallions during the nuzzling and nibbling stages of courtship, or because this first estrus was not accompanied by an ovulation. Not until they are three years old do most young mares show typical female sexual behavior.

Unlike stallions, who are ready to mate year-round, pony mares are seasonally polyestrus, showing periods of estrus from March to September until they are impregnated, but in anestrus and unreceptive at other times. During the breeding season, estrus is cyclic and occurs at about three-week intervals. Each cycle consists of two parts: estrus, lasting about seven days, and diestrus, lasting approximately fifteen days. While in diestrus a mare is not receptive to the sexual advances of the stallion and meets his courtship with aggression.

Estrus is divided into a pre- and postovulatory period, with ovulation occurring about twelve to forty-eight hours before the end of estrus. As estrus progresses the mare becomes increasingly passive toward the stallion, tolerating his approach and olfactory and tactile examination. She frequently urinates and stands with hindlegs spread and tail deflected. Clitoral winking accompanies urination.

Important internal physiological changes follow these behaviors during estrus. Female sex hormones reach highest levels just before ovulation and probably cause the increased receptivity of the mare. High levels of sex hormones also trigger ovulation, the release of the egg from the ovary into the oviduct where it may be fertilized by the sperm of the stallion.

While young mares may pass through several periods of estrus and copulate a number of times during each, older mares may show only a postpartum estrus. This period of receptivity, called the foal heat, occurs seven to ten days after foaling, or after a pregnancy is terminated by a spontaneous abortion. As about eighty percent of older mares are impregnated at this time, they may only show one estrus period per year. While the harem system of social organization would seem to present the harem stallion with many opportunities, mating is really quite restricted in frequency over time.

Because mares come into estrus when pregnancy is terminated, some scientists suggest that stallions practice feticidal behavior. They believe that males who take over a harem or capture a new mare force pregnant mares to copulate with them, an act that may be similar to rape in humans. This forced mating may cause the mare to abort. She quickly becomes sexually receptive again and the stallion impregnates her, furthering his own genes rather than those of another male.

There is little evidence on Assateague to support this intriguing hypothesis. However, in 1983 the stallion Bobby did steal the mare Virgo from his brother John's band and repeatedly mounted her during the first two hours after capture. She tried to escape back to her own band but was driven back. When mounted she tried to back-kick or walk out from under the mount. Bobby persisted, however, until he achieved intromission. Unfortunately, it was not known if Virgo was indeed pregnant at the time (although she had not yet foaled in 1983 while foaling in each of the three previous years), and no abortion was ever noted.

10.
Foaling Characteristics

LITTLE information is available on the length of the pregnancy or gestation period in the Assateague ponies, for many matings and most foalings go unobserved. In domestic horses, however, gestation averages 330 to 340 days, the length influenced by many genetic and environmental factors. Male foals are carried longer than female foals, and mares bred early in the breeding season have somewhat longer pregnancies than those bred in May or June. Similarly, older mares tend to have shorter gestation periods than younger ones, while well-nourished mares foal earlier than those in poor condition.

Foalings show a pronounced seasonality related to the seasonal breeding pattern of the mare and to the environment. While one might expect foals to be born in summer, in warm weather, most Assateague foals come in the spring. About half, fifty-two percent, arrive in May, twenty-two percent in June, thirteen percent in April, and ten percent in July, while fewer than three percent appear earlier, in March, or later in August, or September. Spring's abundant rainfall and mild temperatures also produce luxurious growths of tender young grasses high in nutrients.

Most Assateague pony foals are born during darkness. The hours just before dawn seem most advantageous as it allows the maximum length of daylight for the newborn animal to nurse, steady its feet, and to become familiar with its mother, but most take place between 11 in the evening and 3 in the morning hours.

Pregnant mares display a number of signals as parturition (foaling) approaches. These include "bagging up" (the filling of the teats with milk) and "waxing" (the flow of the colostrum or birth milk

onto the tips of the teats) up to two days before birth, then increased restlessness and profuse sweating, a few hours before the foal is born. However, because most mares foal at night and because many mares nurse the previous year's foal up to the birth of the new foal, these indicators provide little help in predicting foaling times on Assateague.

About an hour before birth, many mares isolate themselves from the band. Either the mare walks away from the group or she lags behind the band until it grazes some distance from her. Some mares move to the cover of shrubs; others remain in the open expanse of the marsh. A mare foaled in the sand beneath one of the concrete bathhouses in the Maryland State Park campground before a crowd of onlookers at five o'clock on the morning of July 4, 1982.

Darkness and separation from the group decrease the likelihood that the new foal may be injured by other ponies or attacked by predators. Some Assateague mares have kicked at newborn foals, and there are reports in the literature of stallions fatally biting them. This infanticidal behavior occurs most commonly after a stallion takes over a harem and harasses colts fathered by the previous stallion.

During parturition, the mare delivers the foal from a position of sternal or lateral recumbency. The foal emerges front feet first, followed by the head, trunk, hips, and hindlegs. At least one mare died in foaling from a "breech birth" (the rear legs were presented first) in which the foal could not be passed. Normal delivery takes about half an hour from the time the mare first lies down.

Assateague mares, like other female horses, bear only one offspring per pregnancy; no twins have been born during the study. Twins are occasionally reported in domestic horses, but most abort shortly after conception.

The precocious foals are born in well-developed condition, covered with hair and eyes open. In their first few hours they may gallop more than a mile beside their mothers and even swim across tidal streams.

After birth, mare and foal usually remain recumbent for up to thirty minutes. The foal crawls forward on its front legs to free itself from the fetal membranes. The mare licks the birth fluids from her hindlegs, then sniffs and licks the foal extensively. Licking not only dries the wet coat of the foal, but also apparently helps establish the bond between mother and young. After a mare cleans her foal, she discriminates between foals, accepting her own but rejecting others.

Mother and foal vocalize with soft nickers and stare at each other, providing apparent visual and auditory cues to help the foal become imprinted or socially attached to the mare.

The rising of the mare or the foal, whichever comes first, breaks the umbilical cord. The foal may try to rise several times before it succeeds, and its first steps are uncertain and lacking coordination. After standing, the foal shows what scientists have called the *following response*. It moves toward its mother and follows whenever she walks away. Experiments have shown that newborn foals tend to follow any large moving object: siblings, other mares, or even humans. To prevent this, perhaps, the mare remains very close to the foal, especially when other ponies are nearby. She threatens any pony who comes too near and moves quickly between any approaching pony and the foal. Mares also nicker to call their foals and keep them close.

Within the first postpartum hour the newborn foal attempts to nurse, standing unsteadily alongside its mother nuzzling her belly. It searches under front and back legs for a teat, and the mare may gently push and nudge it into contact. Contact with the mare stimulates the foal's sucking reflex.

Discharge of the placenta may not occur for up to two hours postpartum, and it is common to see a mare dragging the placenta behind her. Unlike some other mammals, mares do not eat or even lick the placenta, but they do move the foal away from the birth site as soon as possible. The expelled placenta and the accompanying blood and fluids may attract predators' attention.

Mares separated from the group to foal lead the newborn back to the others within three hours of birth. Other ponies often come toward the pair to investigate—generally, the stallion, previous offspring of the mare, other yearlings, or some of the other mares. A mare's behavior on her foal's first day is directed toward keeping the foal near to her and away from other ponies. The mare may bite, then quickly move between the foal and the other pony. She may even kick her hindlegs, even at previous offspring. This aggressive behavior protects the foal from the bites or kicks of other animals as well as from accidental injury. A careless pony recently broke the leg of a foal lying on its side. Unable to nurse, it soon died. Keeping others away from a newborn foal also prevents the newborn from accepting another horse as mother. Only gradually does the mare introduce the foal to her band and lower her defenses against them.

A mare with a newborn foal is a source of interest, and her status in the dominance hierarchy tends to rise. Mares placed just above her become aggressive to defend their rank. When a low ranking mare in B band foaled, the mare just above her in the hierarchy tried to back-kick the foal. The stallion neither attempts to intervene during such encounters nor acts as peacemaker.

Occasionally, foals die from disease, injury, or congenital weakness one to three days after birth. Their mothers exhibit distress, calling the dead foal and galloping around it. When the rest of the band moves away from the dead or dying foal, the mare's stress increases. She remains with the foal, whinnying toward the band, dashing after them but calling back toward the foal. She may continue to move back and forth for more than an hour. Some mares eventually abandon the foal and move off with the band. Other mares may stand alone over the foal for a day or more.

One of the researcher's favorite mares, a brown-and-white pony named Bertha, often chose to remain with him rather than move on with the band, tolerating being petted and accepting occasional handouts. Apparently she and her harem stallion shared some sort of genetic incompatibility: each of their foals died shortly after birth. Bertha stood over one carcass for more than a day and met with a rush any attempt to examine the dead foal. Gradual approaches, however, were met with a series of wide yawns rather than with aggression. Such yawning behavior exemplifies displacement activity, an inappropriate, out-of-context behavior appearing when two opposing tendencies meet in conflict. In this case neither the tendency to protect the foal nor the tendency to interact positively with friends was being shown. Instead, Bertha showed a third behavior, yawning, which served only to reduce the level of anxiety or stress for the mare. Displacement activities are common in animals and are also found in humans. A man, turned down for a raise by his boss but afraid to quit his job and start over, berates his wife or bangs his fist against a wall, for example. Children who are bored in school, but fear the anger of the teacher if they leave the room or fall asleep respond, like Bertha, with several big yawns.

11.
Nursing Behavior

B ECAUSE the foal is born without the large grinding teeth of the adult, it gets most of its food by suckling or nursing. This behavior first occurs an hour to an hour and twenty minutes after birth when the newborn struggles to its feet, searches along the underside of its mother for a teat, and finally consumes the colostrum. Rich in protein, colostrum contains maternal antibodies that give the foal immunity from some diseases. The physical contact during nursing is also important in cementing the mother-foal bond.

Nursing behavior has several separate components: positioning or stance of the body, orienting the head, seeking the teat, and suckling. Newborn foals show a variety of stances during nursing, suggesting that they learn this component rather than inherit it. Foals less than two weeks old often have difficulty maintaining their balance during nursing. They stand facing toward the rear of the mare and lean against her, their heads lifted to the udder. Contact also informs the mare that the foal wishes to nurse.

Some foals try to nurse in a stance with their bodies perpendicular to that of their mothers. Some face in the same direction as the mare, some in the opposite direction. Other foals stand behind the mares with heads extended between their hindlegs to reach the teats from behind. In all these abnormal stances side-to-side contact is missing, and the mares stride away, sometimes kicking their foals in the chin and preventing them from nursing successfully, or even show aggression to the foals. Older foals avoid these stances, probably because they are not successful.

As the foal grows older, it develops a typical nursing posture and continues to use it as long as it suckles. The body of the foal faces toward the rear of the mare in an approximate forty-five degree angle from her body. The foal holds its head slightly below shoulder level, and nuzzles upward into the udder. Because the head of the foal is always directed toward the underside of the mare's belly, usually near a pair of her legs, it appears that this component of nursing behavior is inherited rather than learned.

Once the foal takes the nursing posture and directs its head to the udder, teat seeking or nosing occurs. Most frequent in young foals and lasting many seconds, it is not always followed by suckling. Older foals nuzzle less frequently, but it usually leads to suckling.

During teat seeking, mares help their foals by standing still, by stepping forward to bring the udder closer to the foal's head, and by flexing the hindleg on the other side away from the foal to angle the teats toward the foal's mouth. For older foals, the mare moves or deflects the hindleg on the side of the nursing foal providing it with easier access to the teats.

Teat seeking involves pushing the tip of the nose against the udder, an action that causes release or letdown of milk. At times mares show signs of discomfort to vigorous pushing and try to stop the foals. They will move away, lift their hindlegs on the side from which the foal seeks to nurse to push the foal away, or nip at the foal's hindlegs. Nipping discourages them for a few seconds or more, but they soon return.

Foals initiate most nursing sessions by approaching the mare, often with a soft nicker. These approaches usually follow a period of resting by the foal or a period of separation from the mare. Nursing may also provide a feeling of security, for it often follows aggression, band movement, herding by the stallion, or some other disturbance.

Nursing bouts consist of periods of suckling interspersed with pauses from suckling when the foal shows investigative, play, or maintenance behaviors. As these pauses occur more commonly in younger foals, they may represent periods of swallowing. When a foal resumes nursing after a pause, it may suckle from the other teat or even move around to nurse from the other side of the mare.

Newborn foals nurse from four to seven times an hour (the average nurses about 4.5 times per hour) each hour of the day with an average duration of eighty-four seconds per bout. By hearing rather than seeing this behavior, researchers have discovered that foals

nurse the same way during the night. Foals nurse with such force that the sucking is audible from some distance. As the foal ages, both the frequency of nursing and the duration of the nursing bout gradually decrease so that by ten weeks of age, a foal nurses about once an hour for perhaps sixty seconds. These decreases probably result from the foal's getting more food from grazing and therefore needing less milk. After three months, as long as the foal continues to nurse, it does so at this same frequency and duration. Colts and fillies do not differ significantly in either the number of times they nurse per hour or in the length of the nursing bout at any age.

A mare usually cooperates with her foal during nursing by stopping grazing, standing still, and deflecting the hindleg on the side of the nursing. Newborn foals are small enough to gain access to the teats even while the mare grazes. Foals nurse from both the right and left side of their dam, and most show no side preference. This is probably because a foal on one side can reach and thus obtain milk from both the right and left teat.

Although the mare allows a young foal to drink its fill, she eventually breaks off nursing by moving off. In response, foals show a cutting-off or blocking behavior. They walk quickly after her, then cut in front, passing under her neck. Blocking presents a physical barrier to the mare and gets her to stop so that the foal can reestablish the physical contact necessary for successful nursing. Usually, the foal blocks only once, but sometimes it must cut off the mare several times before nursing resumes. Foals frustrated by their dams paw the ground, canter around her in a circle, or back into her and try to kick. With older foals the mare stands until the foal breaks off nursing and moves off.

While foals nurse, mares do not let other animals approach too close. Instead, they "clear out" a large space around themselves by threatening animals grazing nearby. If the threatened pony does not move far enough away or does so too slowly, the mother often charges and bites it. Such aggression is especially true of dominant mares; subordinate ones try to move their foals away from the rest of the band to prevent interference.

Mares do not knowingly allow foals other than their own to suckle. When foals attempt to nurse from nonmother mares, the mares react by walking away or by exhibiting a more active refusal, kicking or biting the foal. Foals respond to aggression by champing, with ears erect and quickly opening and closing their jaws. This shuts

off the aggression of the mare. The foal then moves off to seek its mother.

While mares protect their foals from other horses, they often are less aggressive toward humans. When one of Bertha's sick foals refused to nurse, a research assistant tried to save the foal by feeding it raw cow milk from a bottle. Another held the foal beside its mother, forced its head to the teats, and got it to nurse. In both cases Bertha showed no aggression. Similarly the foal born under the concrete bathhouse in the State Park was handled by park rangers within the first postpartum hour. Then it moved from the shade of the bathhouse into the sun to dry its wet coat. Other newborn foals have been photographed from only a few feet away without provoking the mare. However, protective behavior varies from mare to mare. Some lead their foals away when approached. Others run between their foal and a human, preventing contact. Because of this unpredictability, it is wise to observe newborn foals from a distance and not try to handle them.

Nursing and protection of the foal are not the only maternal behaviors shown by Assateague pony mares. "Good mothers" whinny to their foals to bring them up from recumbency when the band moves away from the resting site. Other mares do not show this behavior, but simply walk off with the other ponies and leave their foals. Later, the foal arises and cannot find its dam. It runs back and forth across the marsh calling loudly. It may gallop into another band during its searching. Some mares respond by walking back toward the foal and answering its calls. Others simply turn and whinny in the direction of the foal. "Bad mothers" show no response at all and just wait for the foals to find them.

Although domestic foals are weaned anywhere between six and twenty-four weeks of age, most foals on Assateague nurse for almost a full year. There is evidence that the high quality milk of the mare helps the foal survive the first winter, for foals whose mothers have died often do not survive this period. Those that do are stunted and never achieve the size of other foals that continue to supplement their low quality winter diet with milk.

As the foal approaches its first birthday, however, most mares attempt to bring about weaning. They prevent some nursing by threatening the approaching foal or by moving away, and break off others by biting or kicking the foal, and walking off. Foals counter these actions by chasing after the mare and showing "cutting-off"

behavior or by staging a "con job." The foal approaches the mare but instead of immediately trying to nurse, it initiates a bout of mutual grooming. After several minutes of this maintenance behavior, the foal then pushes the head into the udder region and begins to nurse, and such behavior is usually tolerated.

How many months the foal continues to nurse depends on whether its dam bears a foal the next foaling season. Mares that give birth to a new foal wean their year-old offspring by threats or bites just before or immediately after foaling. After weaning, the relationship between a mare and its older offspring remains much as before the birth of the new foal. Although the yearling no longer nurses, it still rests and grazes near its mother, mutually grooming and following after her when she moves to water or to insect refuge sites. However, the yearling now does not walk directly behind the dam but rather walks behind its younger sibling who walks alongside or behind its mother. The yearling, rather than the mare, seems mainly responsible for maintaining the relationship, for it is probably the first animal moved away by the mare during her "clearing out" behavior prior to nursing.

In a few cases weaning fails, and the yearlings continue to nurse after the birth of the new foals. Whenever the foals move alongside the mare to nurse, the yearlings run up. More experienced, the yearlings take up the correct nursing stance and begin nursing while the foals search for a teat. Even when the foal nurses correctly from one side, the yearling simultaneously nurses from the teat on the other side of the mare. Continued nursing by the yearling can deprive a foal of sufficient milk and result in its death. In domestic horses, the continued nursing of a yearling may lead to removing and hand rearing of the foal. On Assateague, however, simultaneous nursing has never lasted more than a few days of the postpartum period before the mare finally weans the yearling.

If its dam does not foal the next year, the yearling will continue to nurse, and the behavioral relationship between mare and offspring continues unchanged. The yearling still nurses about once an hour for a duration of approximately sixty seconds, and the mare usually stands until the younger pony breaks off the sucking. Most yearlings of such mares are finally weaned in late autumn or early winter of their second year, when they are eighteen to twenty months old.

The most unusual situation involving nursing took place on southern Assateague. A filly nursed well into her second year, was

then weaned, but remained close to her dam. The mare foaled the next summer, when her older offspring was two years old, and she nursed the new foal until it was removed and sold at the annual auction. Because the mare had been nursing her new foal, her teats were filled with milk, and her older daughter began to nurse again. The nursing continued into the next winter, when the young female was about thirty months old, sexually mature, and as large as her mother. She still nursed almost once per hour, each nursing bout lasting about fifty-five seconds. The mare made no attempt to wean her and, in fact, would often stand and wait for her approaching daughter to catch up. This bizarre situation finally ended when the mare died in late winter, and it is possible that the stress of having to produce milk to feed so large an offspring contributed to her death.

Nursing occurs in contexts other than that between a mare and her foal. Some young males nurse from dominant mares who are not their mothers, an action that probably shows their acceptance of a subordinate position. Similarly, in a bachelor band a two-year-old male assumed the nursing posture and sniffed and licked the penis of the more dominant four-year-old in deference to his status.

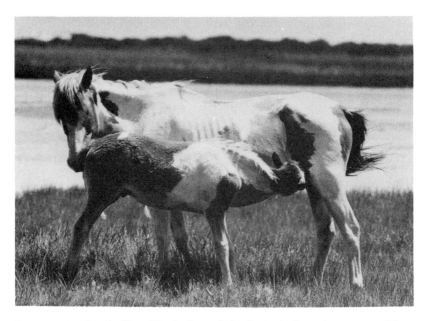

Rose nursing her foal Joe. The foal stands in the typical nursing posture. Note the side-to-side contact.

12.

How Foals Behave
and Interact .

Primarily two activities, nursing and resting, fill the first few days of life for a new foal. Foals nurse about four times an hour and, between nursing bouts, will collapse right into the wet grass of the marsh or onto the hot sand of the beach. They may rest for as long as ninety minutes, then get up, walk slowly to their dam, nurse, and rest again.

Before lying down, foals often seem to be searching for just the right spot. They walk slowly in circles, sniff the ground, sometimes even paw it with a foreleg. Once the suitable spot is found, the foal turns around two or more times and begins to go down. Very young foals often attempt to lie down several times before they succeed. Their immature balance and coordination, apparently, do not yet allow this to be done with ease.

At first, foals usually assume sternal recumbency, resting with their heads up, legs tucked under the body, and weight on the sternum. They may then move to lateral recumbency, lying on the side with head against the substrate and legs extended out from the body. In some cases the legs bend, in others they extend straight out. Foals may alternate between sternal and lateral recumbency, moving from lateral to sternal when disturbed. Or, from the side, they may suddenly roll on the back, tuck legs, and rock back and forth several times before again resuming lateral recumbency. After lying laterally for several minutes, foals usually drop into a rather deep sleep. They can be approached or sniffed by another pony but will not awaken. If there are several foals in a band, they usually lie down at the same time close together—often so close that bodies overlap.

Foals may rest standing as well as lying down. To about three months of age, they lie down for more than seventy percent of the total resting time, but standing resting time gradually increases with age. Foals also tend to stand rather than lie down during periods of rain and cold winds and when the band locates itself in tall grass or shrubs.

During the first few days of a foal's life, its mother stands over it while it reclines, often so close that she almost touches it with her feet. Some mares sniff their recumbent foals, other do not. They will threaten any other pony who approaches the foal. However, as the days pass, the mare begins to graze, while the foal is recumbent, at first in small circles around the foal, then farther and farther away.

Foals spend almost all of their first week of life within fifteen feet of the dam and rarely move more than fifty feet from her. As the foal grows older and gains in confidence and curiosity, it begins to wander off at a greater distance from its dam and spends more time with other foals. Still, a yearling will spend about twenty percent of its time within fifteen feet of the dam.

Newborn foals nibble and suck on grasses and often pull leaves off of marsh shrubs. Many foals, in sternal recumbency, uproot the grasses between their forelegs. Such behavior seems to be more close-ly related to exploring rather than to eating, for foals treat rocks, driftwood, pieces of seaweed, horseshoe crab shells, and soil in the same manner. At about six days of age, most foals' teeth have cut through the gums, and the young animals actively begin to chew and swallow grasses.

A new-born foal gallops around its mother on its first day of life. This galloping is a common form of play, typical of young foals.

Because foals depend on milk for the first few months, they spend fewer than ten minutes grazing per hour. As frequency and duration of nursing decreases about the third month, the amount of time spent grazing gradually increases until reaching the adult level of more than forty minutes per hour at about one year of age.

First-week-old foals do not drink water. Apparently getting sufficient moisture from the milk, they simply stand next to their mothers at water holes. When they begin to try to drink, they at first have great trouble reaching the water because of their long legs. After several tries, though, they learn to spread their forelegs and lower their heads to the water.

Foals begin urinating and defecating during the first day of life, but they generally ignore their own eliminations. Instead they do pay attention to the eliminations of other horses, especially those of their mothers. A newborn may follow its dam so closely that when she stops to urinate or defecate, the foal may get hit with the waste product. Foals smell the urine or feces then evidence one of several reactions. They may show indifference or adopt the flehmen posture. Both colts and fillies show this scent-sampling behavior, but they never raise the tips of their noses as high into the air as do mature stallions. Foals may also paw the elimination, perhaps to get a better scent. They may eat some of the feces or urinate, or defecate in turn. Colts often mark their mothers' elimination as a stallion would.

Coprophagy or feces-eating is common in foals and is even seen in other older ponies. Scientists believe foals benefit from this by acquiring the bacterial flora their digestive tracts need. Why stallions may consume the feces of other stallions is unknown, but it may be related to some form of individual recognition.

When the foal is a week to ten days old, its mother moves into a postpartum estrus state. Instead of the mare chasing the stallion away, she accepts his sexual advances and copulation ensues. Throughout the courtship and mating activity, the foal remains near its mother, often showing great interest in the sexual behavior.

A recumbent foal will rise quickly when the stallion approaches, and will champ toward him, then move to the side or to the front of the mare. These behaviors are important because they prevent the foal from being stepped on as the stallion rushes up to the mare and they tend to reduce or shut off any aggression the stallion may feel toward the foal. The mare, if not completely receptive, may back-kick the stallion, and it is vital that the foal not stand behind the mare, where it may be killed or injured by her kicks.

While foals generally behave much like adults, there are two behavior modes common in foals that rarely appear in animals over a year old: investigation and play.

Foals begin investigating their environment the first day of their lives. First they explore the thing closest to them, their mothers. They do this by sniffing, chewing, and licking parts of their mothers' bodies, and most mares are very tolerant of this. Exploration then gradually extends from the mare to objects and other animals nearby. Foals sniff pieces of wood, mats of seaweed, and seashells. They pound their hooves against the shells of horseshoe crabs, and tear off leaves or grass stems and toss them in the air. Foals also investigate paper bags and pieces of food in the island campground. This frequently results in their exploring garbage cans and tents and becoming the obnoxious "garbage" ponies that plague the National Park Service.

During their exploring period, foals periodically return to their dams, apparently because they find security with her, and the mare serves as a familiar frame of reference.

While adult ponies pay little attention to the cattle egrets strolling around their feet, foals appear to be fascinated by them. They watch the birds intently and often charge at them. This may be an attempt to get them to play, but unfortunately, it only causes the birds to fly away. Perhaps because of this, egrets never perch on the backs of foals and rarely feed near them.

Play begins within hours of birth. It is frequently mixed with exploratory and investigative actions, and it serves a number of functions. Play provides exercise. It allows foals to interact with other ponies where they can develop social contacts and become integrated into the group. Play also helps weaken the bond between foal and mother, as more and more time is spent away from her and with peers. Finally, play behavior is practice behavior; foals practice motor actions and skills they will need to be successful adults.

At first most play is solitary or directed toward the dam. The foal nibbles at the legs and mane of the mare and pulls her tail. It jumps up so that its forelegs rest on the mare's neck or back. Male foals later show true mounting behavior, rising on their hindlegs behind the mare and placing their front legs on her rump. As the mare walks away, the foal runs on its hindlegs behind her for several steps until it loses balance and falls off. Mares are very tolerant of these early play activities and rarely show any negative response.

The most common form of solitary play is called "galloping." The foal jumps stiff legged into the air beside its dam, then it dashes to and from her, often kicking its hindlegs high into the air. Running in small circles around the mare, it jumps over small objects in its path and swerves sharply to avoid bushes. As confidence increases, the circles widen and speed increases.

Sand dunes do not provide the most solid substrate for running, and some foals injure their legs by stepping in holes or slipping in the loose sand. One filly, Celia, damaged her right front leg, probably breaking one or more of the carpal bones. She hobbled on three legs after the moving band and would just about reach them to begin grazing when the band would move off again. Fortunately, Celia had a "good mother" who waited for her to catch up and allowed her to nurse. Though Celia did little grazing, the nutrition obtained from the dam's milk enabled her to survive. At six years of age her lower leg still remained misshapen, and she walks with a limp, but in spite of her handicap, Celia has given birth to several foals of her own.

Foals begin to play with other foals about their second week when they run after another animal galloping across the marsh. As they get older, they move farther from their mothers to approach, sniff, and nibble other foals. Foals three to four weeks of age often engage in vigorous play sessions lasting ten to fifteen minutes. These play periods occur most commonly in the early morning or an hour or two before dark, when the weather has cooled.

Galloping, an example of the most common form of solitary play in young foals.

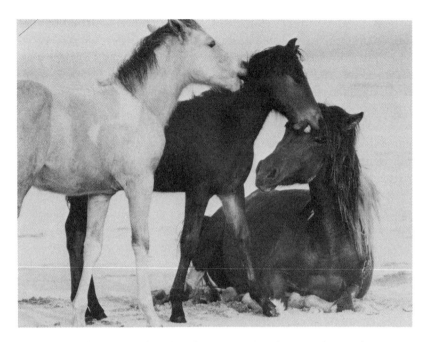

Russ and Mike play with each other and with Mike's mother as she tries to rest.

Play activity often develops from mutual grooming. Two foals begin nipping each other while grooming, and if the actions become more exaggerated and less gentle, a play session ensues. Or, one foal simply approaches another, starts biting, and the two animals begin playing. Sometimes a foal nibbles on a recumbent foal and "pesters" or annoys it until it gets up to play.

Like the fights of stallions, play bouts usually consist of a series of "rounds" separated by periods of other activity. One bout ends when one of the participants runs off or turns its rump to the action. The foals may rest, graze, groom themselves, or begin to mutually groom with a playmate, then, after a minute or two, begin to play again.

Foals seem to prefer to play with others of approximately the same age. It may be that the play of older animals is too rough. Until about four weeks of age, the sex of the playmate seems unimportant, but after that age, colts play with other colts and only play with fillies if there are no colts present in the band, or if the dam of the filly associates with the dam of the colt. Similarly, fillies play with fillies.

A lack of other foals or of foals of a particular sex may hamper the development of a foal. In fact, some scientists believe that the lack of appropriate playmates is an important cause of young ponies' dispersal from the natal band.

The apparent reason colts rarely play with fillies is that the two sexes exhibit different patterns of play behavior. Fillies play mainly by grooming each other and by galloping about in wild chases. They show little biting and rarely rear or try to mount. When colts begin to play with fillies, their play rapidly becomes too rough. They grip their partners' necks or manes, bite at their faces, and attempt to mount them. Fillies respond by attempting to move away, but the colt usually follows and harasses her. The filly finally bites or kicks at the colt or as a last resort moves far enough away to end the bout. Sometimes she runs to her dam who threatens the colt or chases it away.

The play of colts consists of extended periods of rough playing and fighting. Each foal nips at the face, back of the neck, forelegs and hindlegs of the other animal, while prancing and jumping away from the bites of the other. To protect themselves from these bites, colts often drop to their knees to protect their forelegs. This defensive posture, called the "turtle posture" by animal behaviorists, is rarely seen in fights between adult males. However, it does occur in the play-fights of young stallions and in fights between adult male zebras.

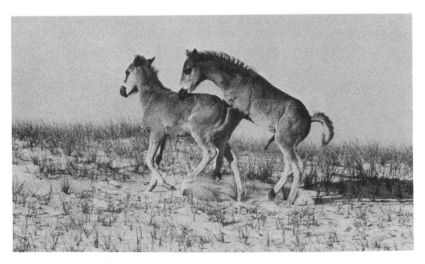

A young colt tries to mount a filly during play.

Colts rear on their hindlegs, much in the style of fighting stallions, and paw at each other with their forelegs. Because this behavior is so important later in life, perhaps determining whether a male controls a harem or not, it appears early in the colt's life and is perfected by practice. Often, a rearing foal comes down with its forelegs draped over the back of its peer. The foal on the bottom attempts to run out from under the mounting foal, sometimes having to run ten to fifteen feet before the other colt drops off its back. The two then gallop off after each other, biting each other's rump, before stopping to play-fight again.

Although an occasional yearling may gallop after a running foal, most ponies over a year old are passive participants in the play behavior of foals around them. They tolerate the biting and pestering of the younger animals without responding aggressively. Several foals often "gang up" on an older pony, one biting the forelegs while another pulls its tail. Even the stallion may not react when a colt dashes up and bites it.

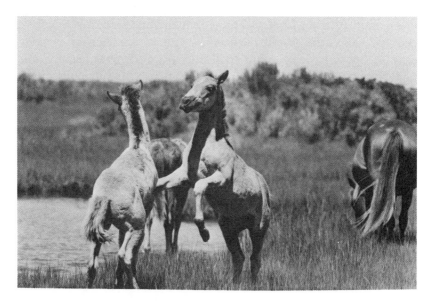

Two colts rear on their hindlegs during a play-fight.

13.
Population Dynamics

A KNOWLEDGE of reproduction is basic to understanding the dynamics of any population. In domestic horses reproduction is measured in terms of rates of pregnancy, where pregnancy is determined by the rectal palpation of mares. Fetal losses during pregnancy are easy to measure because the animals are confined. Because Assateague Island pony mares cannot be examined internally and because of the difficulty of finding dead foals and aborted fetuses in the wild, reproduction on Assateague is measured in terms of the "foaling rate." The foaling rate is simply the percentage of sexually mature mares in the population who produce a foal in a given year. Since no known mare on Assateague has ever foaled during her first or second year of life, a sexually mature mare is considered to be a three-year-old animal.

The unmanaged mares living on the Maryland portion of Assateague have a low and variable foaling rate. The rate ranges from a low of forty percent to a high of seventy percent and averaged just over fifty-seven percent for the years 1975-1984. This figure is comparable to foaling rates for mustangs in the western United States, for free-ranging horses on Sable Island off the coast of Nova Scotia, and for horses in the New Forest region of Great Britain. These foaling rates, however, rank much lower than the eighty percent reproductive efficiency achieved in domestic horses.

The foaling rate for mares living on the southern Virginia portion of Assateague Island runs much higher (seventy-four percent over the years 1975-1980) than that on the northern portion and approaches that of domestic ponies. The difference in the foaling rate between

the northern and southern populations probably results from the effects of human management on the latter animals. These ponies receive minimal veterinary care such as tetanus and equine encephalitis vaccination. More important, most southern foals are removed from their dams at six to twelve weeks and sold at the annual auction. Southern mares, therefore, do not have to nurse one foal while gestating another during the harsh Assateague winter. Northern mares, on the other hand, must obtain enough nutrition from the low-quality winter vegetation to feed a developing fetus in the uterus, nurse last summer's foal, and remain healthy themselves. In times of the nutritional stress produced by bad weather, the developing fetus is sacrificed and a spontaneous abortion may occur. Scientists estimate that about fifteen percent of domestic horse mares abort. If a similar rate of abortion occurs in the northern mares, those losses, added to the foaling rates observed, would produce a reproductive efficiency close to that of domestic animals and comparable to the southern population.

In addition to variable abortion rates related to weather, the difference in the foaling rate on Assateague over the years and between these animals and domestic horses could also be ascribed to variations in the conception rates of the mares, the age structure of the population, and the negative effects of inbreeding. Scientific literature suggests that nursing a foal suppresses ovulation and prevents pregnancy. According to this, if a large number of mares foaled one year, lactation would prevent their pregnancy the next year, and the foaling rate would drop. While foaling rates do vary, they do not follow this pattern. For example 70.6 percent of northern Assateague mares foaled in 1977 while 70.0 percent foaled in 1978.

The fluctuation in the foaling rate from year to year could relate to the percentage of young mares in the population. Because the birth date, and thus the age, of most mares is known, it can be shown that younger mares foal at a lower rate than older mares. Only 27 percent of three-year-old mares foal. This percentage rises to 41 percent for four-year-olds, 53 percent for five-year-olds, and 68 for six-year-old and older mares. In 1977, when the foaling rate was over 70 percent, only 17 percent of the sexually mature mares were under five years of age. On the other hand, in 1980 and 1981, three- and four-year-old mares made up over 40 percent of the breeding population and the foaling rates dropped to 56.7 percent in 1980 and just 44.2 percent in 1981.

In domestic horses there is little relationship between the age of a mare and her foaling rate. Even yearling females conceive, and while most abort their fetuses, more than twenty-five percent bear live foals. Two-year-old mares foal at a rate comparable to older females. The failure of even two-year-old animals to foal at Assateague, and the lowered foaling rates of females up to about six years old, are probably related to the inadequate nutrition which results in slow physical and physiological development.

Inbreeding could also influence the foaling rate. About a quarter of all young mares do not disperse from their natal band but remain there and are bred by their father. These mares show a foaling rate of only 22.7 percent, although much variation exists between mares. A pinto (Betty) foaled five times in seven years after being bred by her father (Mort), but her older sister (Marianne) never produced a live foal in seven years of breeding to the same stallion. Some young mares who left their natal band spent breeding periods in a band controlled by a half-brother, a stallion having the same father but a different mother than the mare. These mares have a higher foaling rate, 36.8 percent. Most mares, however, breed with an unrelated stallion, and these mares with inbreeding not a factor, show a foaling rate of 61.8 percent. There have been no known inbreeding cases yet on Assateague where a son bred its mother or a full brother and sister mated.

In addition to determining how many mares foal in a given year, reproduction may also be studied by observing mares of known age to see how frequently they produce a foal. The foaling frequency for twelve mares living on the northern portion of Assateague and known to have been sexually mature in 1975, was monitored for nine years. While none of the mares foaled in each of those years, none of the mares failed to foal at all. Half of the mares gave birth to seven foals over the nine years. Four of those foaled in four consecutive years before failing to foal. Two bore five foals in a row before skipping a year. Two old mares (Irene and Rose, who died in 1980 and 1981, respectively) each foaled for seven consecutive years and each produced a foal the summer before she died. In both cases the foal perished along with the mare, probably because of malnutrition.

Mares in stable harems produce more foals and foal more frequently, presumably because of higher abortion rates in females in less stable family bands. In T band, for example, almost every sexually mature mare gave birth for each of the years 1982-1984. In N

band, which was initially the same size as T, however, only two foals were born to ten mature mares in 1984 after the band had been split into three bands by young stallions stealing mares.

The sex ratio of Assateague foals has varied widely from year to year. For example, of the twelve foals born on the Maryland portion of Assateague in 1977, eleven were fillies while only one was a colt; similarly, twelve of fifteen foals born in 1981 were female. But for the ten-year period 1975-1984, the sex ratio was almost exactly one colt to one filly.

Some scientists have suggested that the sex of the foal will vary with the age or social status of the mare. According to this hypothesis dominant mares will produce sons because healthy male offspring would be good competitors and have the greatest chance of acquiring harems. On Assateague, however, there seems to be little correlation between the age of a mare, her position in the dominance hierarchy, and the sex of her offspring. Nina, the dominant mare in T band for over five years, produced four fillies and no colts during that period. On the other hand, Rose, during her years as the dominant mare of M band, produced five male foals (three colts in a row, in 1973, 1974, and 1975) and two female foals. Three of those males (John, Bobby, and Teddy) did go on to become harem stallions and, in the past three years, they have produced almost half of the foals born in Maryland.

Reproduction influences the size and the structure of the pony population on Assateague. More than one hundred and twenty-five foals have been born on the northern part of the island since 1975 while only about thirty deaths have taken place. As a result, the population has increased from only forty-two ponies in 1975 to almost one hundred and twenty animals in 1984.

The age and sex structure of this population has also changed over the years. In 1975, male ponies made up about forty-six percent of the population; today that figure is only thirty-eight percent. Similarly, yearlings and sexually immature two-year-olds comprised only twenty-three percent of the 1975 population but today make up more than forty-three percent. These figures suggest that the population is young, with many females just entering the breeding stock, and should continue to increase at a fast rate. The decrease in the percentage of males is also related to the size of the population. In 1975, when the population was low, bachelor males had room between harem bands to live unmolested by the harem stallion. As the size and density of the population increased and new harem bands

filled in home range spaces between established harem bands, young males were aggressively forced to abandon the island or disperse down the island into Virginia.

The sex and age structure of the southern herd differs markedly from that of the northern and results from the effects of human management. The sex ratio for adult ponies is 1 male to 4.6 females, about twice the ratio (1 male to 2.4 females) of the northern herd, a result of the selective sale over the years of colts at the annual auction.

The annual auction also has a great effect on the age structure of the southern population. Adult ponies comprise almost 60 percent of the ponies in the Virginia herd, compared to less than 40 percent of the northern population. Furthermore, there are a few animals in the immature (8.12 percent of the total southern population) and yearling (3.89 percent) age classes, compared to over 30 percent immatures and 15 percent yearlings in the Maryland herd.

Unlike the northern population, the size of the southern herd has not increased. In fact, because of the destruction of the ponies tested positive for equine infectious anemia (EIA), the population dropped from more than one-hundred-twenty ponies in 1975 to fewer than one hundred in 1978. It has been maintained at that level since because the annual sale of foals prevents any significant increase. Foals not sold at the auction or born after the sale offset any deaths occurring during the year.

Counteracting the influence of reproduction on the population is mortality. About ten percent of the foals born on the Maryland portion of Assateague have died during their first year. Half of those foals were male, indicating no mortality differential based on sex. Older mares were no more likely to lose their foals after birth than younger mares.

Some of the foals died within a few days of birth from a disease or from a congenital condition. Typically, they are seen with their dam one day, are missing the next, and never appear again. One mare, foaling for the first time, abandoned her foal in the marsh. When park rangers found the foal and took it to a private horse farm for care, it was suffering from an infection around the umbilical cord and from dehydration.

As a foal ages, it is faced with other dangers. Each year at least one foal is killed by an automobile as it crosses one of the island's roads. While the annual swim through almost a quarter mile of water would

seem to pose a threat for a foal, no foal has ever been lost during the swim. Foals judged too young to complete it successfully are transported from Assateague to Chincoteague by boat.

Some foals die when their mothers perish. Even if the foal is nine or ten months old, it apparently may still not be able to survive the stress created by a severe winter combined with the poor nutrition that results from premature weaning.

Among older ponies, mortality results from a variety of causes. Adults are also killed by cars or injured so badly they must be destroyed by the Park Service. They suffer from diseases like equine infectious anemia and equine encephalitis. Outbreaks of both diseases were recorded in the Virginia population in the mid-1970s but have not been documented in the Maryland herd. On the other hand, the Assateague ponies are not bothered for some reason by colic or founder, common ailments of domestic horses. Young males and some young females suffer from infections that start in bite wounds administered during the aggression that occurs around the time of dispersal. As most dying animals are not found, and autopsies are not performed on those discovered, little is known about the exact causes of most deaths.

Foaling year after year has its own perils and may explain why stallions live longer than mares. One mare was found who had died during foaling; other mares who may have died similarly have not been found. The stress of nourishing a developing fetus, nursing an older foal, and feeding herself undoubtedly physiologically exhausts a mare and makes her susceptible to death by other causes.

Most Assateague ponies live only about twenty years, approximately two-thirds as long as their domestic counterparts. The abrasive diet wears down the teeth of the animals so that as they get older, they became less and less able to grind up vegetation and extract nutrients from it. While the immediate cause of death might be disease, the underlying cause is malnutrition. One Assateague pony bought at the annual auction lived to be thirty-five years old, having been fed a high quality diet all its life, and, in old age, soft food.

While there is not a "pony burial ground" where all Assateague ponies go to die, most dying animals do leave their band and wander off. They tend to move out of their normal home range and die at some other part of the island. When Rose died in January of 1982, she wandered down the island about six miles below the normal range of her band. Similarly, when four-year-old stallion Mike died of an

infection resulting from a bite, he had walked all the way north to the tip of Assateague, several miles above the home range of O band. Dying ponies wander off by themselves or, sometimes, are accompanied by another pony. Both Rose and Irene were followed to their place of death by offspring who were still nursing. When a pony band happens upon a dying pony or the carcass of a dead animal, they show no special interest or any sign of remorse.

Neither the Chincoteague firemen nor the National Park Service normally removes dead animals. A free-ranging Assateague pony, who drew the nutrients for its bones and muscles from the grasses of the island, recycles those raw materials back into the soil upon death.

14.
Impact of the Ponies
on the Island

THE United States National Park Service, who supplied funding for this research, solicited certain information in order to establish appropriate management policies toward the ponies which would be based on fact rather than fiction. The policies should maximize visitor enjoyment and utilization of park facilities while maintaining a high level of public safety and allow the ponies to remain in the feral state living in harmony with the fragile barrier island ecosystem.

The first question asked by the National Park Service concerned the effects of grazing by the ponies on the vegetation of the island. Feral herbivorous mammals have destroyed the endemic tree cactus on the Galapagos Islands and have caused the disappearance of over sixty kinds of plants on Santa Catalina Island off the coast of California. In Hawaii, removal of vegetation by grazing has been so severe that extensive erosion has occurred.

Exclusion cages were used to study the effects of pony grazing on Assateague. This method has been widely applied by scientists to study the ecological effects of goats, deer, elk, and other large grazers. In 1977-1978 ten exclusion cages were constructed on the primary dunes and in the salt marsh on different sections of the Maryland portion of Assateague. Each cage consisted of a five-square-meter area that was surrounded by a single strand of barbed wire strung seventy-eight centimeters above the ground, sufficient to keep the ponies from entering the cages.

The ponies were excluded from the vegetation within the cages, but often grazed just outside the wire. Some of the ponies used the metal poles supporting the wire as a scratching post for heads, necks,

Building exclusion cages on the dunes to study the effects of pony grazing on dune vegetation.

or rumps. In the fall, at the end of the growing season, vegetation samples were cut from inside and outside the cages. The collected vegetation was dried, weighed, and statistically analyzed.

Results suggested that the grazing action of the ponies has little effect on saltmarsh vegetation. On the dunes, however, samples taken in the past two years from outside of the cages on some parts of the island have weighed significantly less than samples from within. Increased population levels could aggravate this situation and lead to over grazing, even dune destruction, making continued monitoring of grazing effects necessary.

Another important question is the carrying capacity of the Maryland portion of Assateague Island—that is, how many ponies can that part of the island support? To determine this figure, two kinds of information were needed: the amount of vegetation present on Assateague and available to the ponies and the amount of vegetation consumed by the ponies.

Information on the quantity of vegetation was collected in 1978-1979 using transects established at 0.4 mile intervals along the entire length of the Maryland portion of the island. At each chosen location, three different transects were run: one on the primary dune, one in

the inner dune zone, and one in the salt marsh. At each location a one-hundred-foot tape was laid in an east-west direction. Sampling was done at ten-foot intervals along the tape. At that point a two foot by two foot wooden frame was centered over the tape, and all of the plants within the sampling area were identified and counted. A separate record was maintained indicating how many stems and plants were found to be grazed and how many were ungrazed. This revealed that the ponies presently consume less than one percent of the available forage.

The amount of vegetation consumed by the ponies was determined by directly observing certain ponies as they grazed. Because the ponies are acclimated to human beings, researchers could stand close enough to count the number of bites of vegetation they took in a one-minute period. The amount of forage taken per bite was determined by immediately chasing a pony away after a bite, then counting the number of grazed stems. By measuring these against ungrazed stems, an estimate of the total amount of forage consumed per bite was calculated. Total daily consumption was then determined by multiplying the total daily hours of grazing by the number of bites per hour by the amount consumed per bite. Multiplying this figure by 365 days produced the yearly food consumption of each pony. Carrying capacity was determined by dividing the yearly amount of forage consumed by one pony into the total amount of vegetation available.

When this procedure is followed, an estimated or theoretical carrying capacity of about fifteen hundred ponies results. This figure assumes total consumption of available forage which would expose the island to severe erosion, no competition for forage with other plant eaters (like the white-tailed and Sika deer, mice, and cottontail rabbits), an equal distribution of the ponies over the island rather than their living in restricted home ranges, and the same production of vegetation year after year despite variations in the weather. As none of these assumptions is very realistic or valid, a more realistic carrying capacity of ten percent of the theoretical figure, or one-hundred-fifty ponies, was recommended.

Human interaction seems also likely to limit the number of ponies allowed to wander freely on Assateague. Many of the one-million-plus visitors to Assateague seek out the ponies. As the pony herd has increased and more ponies spend more time in the campgrounds, so also has the incidence of personal injury and property damage risen. In 1975 only three young males lived in the camp-

Petting the ponies is a potentially dangerous activity. The ponies are unpredictable and can bite and kick.

grounds, but by the summer of 1983 some forty ponies (more than one-third of the Maryland herd) spent about thirty percent of their time in the Maryland State Park or National Park Service campgrounds. Visitors are being bitten and kicked by ponies, and tents, screen houses, and cooler chests are being damaged. In addition, the ponies rip open the garbage bags in campsites and knock off the lids or tip over the metal garbage cans, pulling out the contents and littering them over the landscape. Park employees must divert time and energy from other projects to clean up litter.

There are also some negative consequences for the ponies who interact with people. Attracted to roadsides by possible feeding opportunities, they have become more vulnerable to injury from automobiles. This feeding also draws them into small areas resulting in encroachment on each other's personal space and increased aggression among them. Finally, feeding the ponies atypical food items can change their intestinal flora, particularly detrimental during the winter period of poor nutrition.

Therefore, researchers have also been examining people-pony interactions. In 1977, more than eleven hundred questionnaires were handed out to campers to determine their knowledge of and attitudes about the Assateague ponies. Approximately forty-five percent of the surveys were completed and returned for analysis.

Teddy, a bachelor stallion, looks for food and relief from flies on the beach. Bathers often kill flies or chase them off the ponies.

More than two-thirds of the questionnaire respondents said they had seen the ponies during their stay on Assateague, and most knew that the ponies fed on dune and marsh grasses and drank from fresh-water ponds (rather than being fed and watered by the park service). Most agreed that ponies who destroyed property or caused human injury were troublesome; but they were not annoyed with those who blocked roads and traffic or took food from garbage cans and campsites.

Asked what should be done with troublesome ponies, more than half those responding felt nothing should be done. Fewer than two percent believed that such animals should be destroyed. The respondents did agree with the concept of transferring "bad" ponies to another part of the island as long as such action was not detrimental to the pony. Almost forty-four percent of the respondents favored the idea of establishing special feeding areas from which the ponies could obtain food (rather than from the campgrounds). Not only would this procedure be costly for the park, it would also make the animals much less wild and more dependent on handouts.

About fourteen percent of the respondents had experienced property damage or suffered personal injury. Surprisingly, their answers

did not differ on most questions from those who had not experienced any people-pony interaction. More than sixty percent agreed that no action should be taken against troublesome ponies. The attitude of most respondents seemed to be that the ponies were on the island first and should retain their freedom.

When the carrying capacity figure of ponies for the island was calculated in 1979, the pony population on the Maryland portion of Assateague was about sixty animals, and the need for management seemed distant. By 1984, the size of the herd had increased to the point where control of the population is, or soon will be, needed. Several population-control ideas have been considered, one of which was to perform vasectomies on harem stallions. But this surgical procedure would not only be costly, it might also alter the behavior of the stallion, leading to his replacement by a younger reproductively-intact male. Relocation of bands from the campgrounds to more remote parts of the island sounds appealing, but such animals usually return to their former home ranges within a few days. Destruction of certain ponies, inexpensive compared to other solutions, would probably be unacceptable to the general public.

Teddy and his sister Jackie on the Maryland State Park beach. Note the radiotelemetry collar with its box-shaped transmitter.

The best solution seems to be selective removal of animals from the northern population. These ponies could be sold or transferred to the southern herd. Removal following age and sex criteria would prevent upsetting the normal age and sex structure, or could involve only foals or only ponies causing trouble. During the summer of 1983, researchers studied the behavior of campground bands. They recorded which ponies blocked traffic, which tipped over garbage cans, and which showed aggression toward humans. Some mares, like the chestnut Cassie, constantly fed on garbage; but others, like the red-and-white mare Allie, never engaged in such behavior. Foals of "garbage mares" tended to pick up the behavior from their dam. The most aggressive ponies were the stallions Bobby, harem stallion of B band, and Charlie, the stallion of C band. Even so, fewer than forty aggressive actions were seen in more than 150 hours of observation of bands containing between nine and thirteen ponies, and many of these were threats rather than bites or kicks.

In the spring of 1984 a selective round-up was conducted based on the data collected the previous summer. Thirteen of the most troublesome animals were captured, tested to see if they were suffering from equine infectious anemia, transported by horse-trailer to the southern part of Assateague, and released into the Virginia herd.

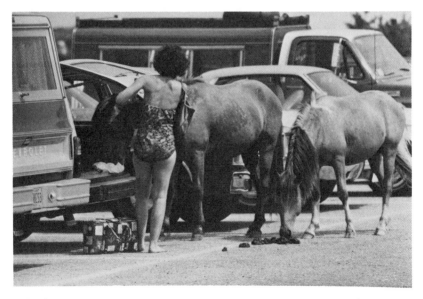

A bachelor male steals food from the trunk of a car in the state park.

None tested positive for EIA and none have returned to the Maryland portion of the island. In addition to removing these troublesome ponies, this action also contributed to slowing the growth of the herd. Six adult mares and two fillies were transported off the Maryland portion, and that should translate into a lower foaling rate and a slower increase in the population.

Continued monitoring of campground ponies will occur so that trouble-makers could again be removed when necessary. Removal of such animals and regulation of population size is needed to ensure that there will always be wild ponies roaming the dunes and marshes of Assateague for generations of humans to observe and enjoy.

Glossary

Antithesis. The situation in animal communication where opposite or contrasting signals are sent in forms that are directly opposite or in contrast.

Browse. The method of feeding in which the tender shoots, twigs, and leaves of trees are consumed.

Carnivore. An animal that feeds on the flesh or tissues of other animals.

Champing. The submissive behavior shown by immature ponies where the head is extended toward the stallion, the ears are held erect or toward the lateral, and the corners of the mouth are drawn back. The mouth is then rapidly opened and closed without the lips and teeth actually making contact.

Chestnut. A pony having a body color of any shade of brown or reddish-brown with a mane, tail, and lower legs of a lighter shade.

Clearing out. The action shown by many mares prior to nursing whereby the animal threatens to bite any ponies other than the foal in an area immediately around the mare, forcing them to move away and creating an empty envelope of space.

Clitoral winking. The rhythmic pulsing of the clitoral tissue of a female pony following urination and during the peak of estrus.

Coggins test. A blood test administered to horses and ponies that indicates the presence of antibodies to the disease Equine Infectious Anemia. A positive test means that antibodies are present and that the animal now has the disease or had it at sometime in the past.

Colostrum. The milk produced by a mare for a few days after parturition that is characterized by a high protein and antibody content.

Colt. The term given to a young male horse or pony less than one year of age.

Congenital. A condition existing or dating from birth.

Cutting off. The action performed most commonly by a foal toward its mother whereby the younger animal passes close in front of the older animal, forcing her to stop walking and allowing the foal to begin to nurse.

Dam. The female parent of a foal; its mother.

Displacement activity. An inappropriate, out-of-context behavior seen when two opposing tendencies are in conflict. The conflict prevents either of the opposing behaviors from occurring, and instead the animal performs an action that is not proper or appropriate for the situation.

Equine encephalitis (encephalomyelitis). A viral disease of horses and ponies characterized by inflammation of the brain and spinal cord. The disease can be transmitted to humans by biting insects. It is usually fatal to Assateague ponies.

Equine infectious anemia. A disease of horses and ponies characterized by destruction of the red blood cells leading to weakness and death in many cases.

Estrus. The physiological state of a female pony when she will accept the male and may be capable of becoming pregnant.

Feral. An animal that has been domesticated at some previous time but has since reverted to the wild.

Feticide. The act of killing a fetus.

Filly. The term given to a young female horse or pony less than one year of age.

Flehmen. The stereotyped posture shown by ponies in response to odor. The head is elevated and extended high above the horizontal and the upper lip is curled back to reveal the teeth.

Foal. The general term applied to any young member of the horse family under one year of age.

Gestation period. The pregnancy period; the period of time the fetus is developing in the uterus. In equines this period is approximately three hundred and forty days.

Graze. The method of feeding in which grasses or other nonwoody plants are consumed.

Hand. A unit of measure used for horses or ponies and equal to four inches.

Harem band. A stable unit of social organization seen in the Assateague ponies and composed of a group of females and their offspring that are associated throughout the year with one male pony.

Harem stallion. The only sexually mature male pony found in a harem band.

Herbivore. An animal that feeds on plants or plant material.

Herding. The behavior used by a harem stallion to control the movement of the ponies in his harem. The ears are pressed tightly to the head, the neck is extended, and the head is lowered toward the ground.

Home range. An area to which the activities of an animal or group of animals is confined but which is not defended.

Incisor. One of the front teeth of a pony adapted for biting or cutting.

Induced urination. Urination by an estrus mare of a small amount of urine triggered by the proximity and behavior of a stallion.

Infanticide. The act of killing an infant.

Metabolism. The process in living animals by which food is converted to energy and raw materials which can be used to replace worn or damaged parts or for growth.

Molar. A tooth in the rear of the mouth of a pony with a flattened surface adapted for grinding.

Natal band. The band of ponies into which the animal was born.

Parallel prance. A stereotyped posture shown by stallions during an aggressive encounter. The head and tail are held high, the neck is strongly arched, and the legs are lifted high off the ground in an exaggerated trot.

Parturition. The action or process of giving birth.

Postpartum. The term applied to the period following parturition.

Precocious. The condition where the young is born well developed and is capable of a high degree of independent activity shortly after birth.

Premolar. A tooth in the mouth of a pony that is situated just in front of the molar teeth. Like the molars, it is flattened and specialized for grinding.

Ritualized. A posture or behavior that is repeated without variation by all members of a species.

Social facilitation. The situation where an action or behavior by one animal serves to trigger, release, or cause that same behavior or action in adjacent animals.

Sorrel. A dark, reddish-brown pony with a reddish or orange-colored mane and tail.

Spanish barb. A breed of horses originally from southern Spain and derived from the Moorish horses of North Africa. The breed is related to the Arabian breed and is noted for its speed and endurance.

Stallion. The name given to an uncastrated male pony over one year of age.

Stud pile. The mass of fecal material that accumulates at certain places within the home range of a pony band as the result of the repeated marking behavior of the harem stallion.

Symbiosis. The close association or union of two dissimilar animals into a mutually beneficial relationship.

Tending. The term applied to the behavior shown by a stallion toward an estrus mare whereby he isolates her from the other ponies in the band and remains physically close to her over long periods of time.

Territory. An area of exclusive use that is defended by an animal or group of animals.

Vomeronasal organ. A specialized region in the lower or ventral part of the nasal chamber of a pony that contains special sensory receptors that respond to odors.

Wean. The process of getting a young animal to refrain from nursing.

Withers. The highest point or bump on the back of the horse that corresponds anatomically to the ridge between the shoulder bones.

Yearling. A pony of either sex that is one year old and is entering its second year of life.

Selected References

Berger, J. 1977. Organizational systems and dominance in feral horses in the Grand Canyon. *Behavior, Ecology, and Sociobiology* 2:91-119.
———. 1983. Induced abortion and social factors in wild horses. *Nature* 303:59-61.
Duncan, P. 1980. Time budgets of Camargue horses. II. Time-budgets of adult horses and weaned sub-adults. *Behaviour* 72:26-49.
Duncan, P. and P. Cowtan. 1980. An unusual choice of habitat helps Camargue horses to avoid blood-sucking horse-flies. *Biology of Behavior* 5:55-60.
Eline, J. and R. Keiper. 1979. Use of exclusion cages to study grazing effects on dune vegetation on Assateague Island, Maryland. *Proceedings of the Pennsylvania Academy of Science* 53:143-44.
Feist, J. and D. McCullough. 1975. Reproduction in feral horses. *Journal of Reproduction and Fertility Supplement* 23:13-18.
———. 1976. Behavior patterns and communication in feral horses. *Zeitschrift für Tierpsychology* 41:337-71.
Ford, B. and R. Keiper. 1979. *The island ponies: An environmental study of their life on Assateague*. New York: William Morrow & Co.
Ginther, O. 1979. *Reproductive biology of the mare: basic and applied aspects*. Cross Plaines, Wisconsin: O.J. Ginther.
Houpt, K. and R. Keiper. 1982. The position of the stallion in the equine dominance hierarchy of feral and domestic ponies. *Journal of Animal Science* 54:945-50.
Kaseda, Y. 1981. The structure of the groups of Misaki horses in Toi Cape. *Japanese Journal of Zootechnical Science* 52:227-35.
———. 1983. Seasonal changes in the home range and the size of harem groups of Misaki horses. *Japanese Journal of Zootechnical Science* 54:254-62.
Keiper, R. 1976. Social organization of feral ponies. *Proceedings of the Pennsylvania Academy of Science* 50:69-70.

————.1976. Interactions between cattle egrets and feral ponies. *Proceedings of the Pennsylvania Academy of Science* 50:89-90.

Keiper R. and L. Keiper. 1978. A survey of visitor knowledge, attitudes, and judgement of feral ponies on Assateague Island. *Proceedings of the Pennsylvania Academy of Science* 52:136-42.

Keiper, R. and M. Keenan. 1980. Nocturnal activity patterns of feral ponies. *Journal of Mammalogy* 61:116-18.

Keiper, R. and J. Berger. 1982. Refuge-seeking and pest avoidance by feral horses in desert and island environments. *Applied Animal Ethology* 9:111-20.

Keiper, R. and K. Houpt. 1984. Reproduction in feral horses: an eight-year study. *American Journal of Veterinary Research* 45:991-95.

Miller, R. 1981. Male aggression, dominance and breeding behavior in Red Desert feral horses. *Zeitschrift für Tierpsychology* 57:340-51.

Olsen, F. and R. Hansen. 1977. Food relations of wild free-ranging horses to livestock and big game, Red Desert, Wyoming. *Journal of Range Management* 30:17-20.

Rubenstein, D. 1981. Behavioural ecology of island feral horses. *Equine Veterinary Journal* 13:27-34.

Salter, R. and R. Hudson. 1982. Social organization of feral horses in western Canada. *Applied Animal Ethology* 8:207-23.

Turner, J., A. Perkins, and J. Kirkpatrick. 1981. Elimination marking behavior in feral horses. *Canadian Journal of Zoology* 59:1561-66.

Tyler, S. 1972. The behaviour and social organization of the New Forest ponies. *Animal Behaviour Monographs* 5:85-196.

Waring, G. 1983. *Horse behavior: the behavioral traits and adaptations of domestic and wild horses, including ponies.* Park Ridge, N.J.: Noyes Data Corp.

Wells, S. and B. von Goldschmidt-Rothschild. 1979. Social behavior and relationships in a herd of Camargue horses. *Zeitschrift für Tierpsychology* 49:363-80.

Welsh, D. 1973. The life of Sable Island's wild horses. *Nature Canada* 2:7-14.

————. 1975. Population, behavioural and grazing ecology of the horses of Sable Island, Nova Scotia. Ph. D. diss. Dalhousie University.

Index